MICHAEL FREEMAN'S PHOTO SCHOOL
LIGHT & LIGHTING

EDITOR-IN-CHIEF **MICHAEL FREEMAN**
WITH **CATHERINE QUINN**

ILEX

First published in the UK in 2012 by

I L E X

210 High Street
Lewes
East Sussex BN7 2NS
www.ilex-press.com

Publisher: Alastair Campbell
Associate Publisher: Adam Juniper
Creative Director: James Hollywell
Managing Editor: Natalia Price-Cabrera
Specialist Editor: Frank Gallaugher
Editor: Tara Gallagher
Senior Designer: Kate Haynes
Designer: Lisa McCormick
Colour Origination: Ivy Press Reprographics

British Library Cataloguing-in-Publication Data
A catalogue record for this book is available
from the British Library

ISBN: 978-1-908150-28-8

Printed and bound in China

10 9 8 7 6 5 4 3 2 1

Photo on page 2 © Adastra
Photo on page 4 © Frank Gallaugher
All other photography © Michael Freeman
unless otherwise noted.

Contents

MICHAEL
FREEMAN'S
PHOTO
SCHOOL

FOREWORD

About This Series

Photography is what I do and have done for most of my life, and like any professional, I work at it, trying to improve my skills and my ideas. I actually enjoy sharing all of this, because I love photography and want as many people as possible to do it—but do it well. This includes learning why good photographs work and where they fit in the history of the craft.

This series of books is inspired by the structure of a college course, and of the benefits of a collective learning environment. Here, we're setting out to teach the fundamentals of photography in a foundational course, before moving on to teach specialist areas—much as a student would study a set first-year course before moving on to studying elective subjects of their own choosing.

The goal of these books is not only to instruct and educate, but also to motivate and inspire. Toward that end, many of the topics will be punctuated

by a challenge to get out and shoot under a specific scenario, demonstrating and practicing the skills that were covered in the preceding sections. Further, we feature the work of several real-life photography students as they respond to these challenges themselves. As they discuss and I review their work, we hope to make the material all the more approachable and achievable.

For you, the reader, this series provides, I hope, a thorough education in photography, not just allowing you to shoot better pictures, but also to gain the same in-depth knowledge that degree students and professionals do, and all achieved through exercises that are at the same time fun and educational. That is why we've also built a website for this series, to which I encourage you to post your responses to the shooting challenges for feedback from your peers. You'll find the website at: www.mfphotoschool.com

Student Profiles

Kelly Jo Garner

Kelly Jo Garner is a photographer and web designer living in Nashville, Tennessee. Her professional interest in photography dates to 1994 when, during a trip to Russia, she captured a shot of a rich yellow building against a startlingly cerulean sky. "I had so many comments about that shot when it was developed and I showed it to friends and family," she says. "Ever since then, I've been hooked." Familiar with both wet process and digital photography, Kelly Jo shoots mainly with her Pentax K7 DSLR and a small Nikon point-and-shoot. Kelly Jo photographs roller derby, portraits, weddings, still lifes, animals, casual street scenes, and anything else that strikes her fancy.

"The difference between documenting and experiencing is a fine line—I want to experience as much as possible, but making sure to document the experience is important too."

Kelly Jo can be reached at www.hungryphotographer.org or on Twitter @kellyjogarner

Sven Thierie

Sven Thierie is a graphic designer living in Leuven, Belgium. He studied graphic design at Provinciale Hogeschool Limburg in Hasselt (PHL), and went on to earn a masters in interactive design at Koninklijke Academie van Schone Kunsten in Ghent (KASK). He is passionate about his work in advertising, but his favorite pastime has always been photography. During his many travels throughout Europe and North Africa, his camera is his "first mate," and an indispensable component of his travel experiences.

A passionate observer of culture, he says that "Living in the center of Europe is very inspirational, personally and professionally, because of the huge numbers of cultures living and interacting so close to one another." In the future he wants to venture farther out into the world, with his camera in tow, of course.

You can see more of Sven's work on his website: www.sventhierie.be

Jennifer Laughlin

After taking a black-and-white photography class for fun, Jennifer Laughlin's interest in photography was stoked and she attended Randolph Community College in Asheboro, NC, graduating with a concentration in biocommunications photography. She has worked at the North Carolina Office of State Archaeology and TTW Photographic. Jennifer works with both film and digital equipment, using a Nikon D300 and a Mamiya C330 to capture her photos. Her specialty is macro-photography and she enjoys portraying the small details in her subjects. Jennifer currently resides in Charlotte, NC with her boyfriend, Chris Badger, and her two dogs, Buster and Griswald.

You can find her work at jenniferlaughlin.blogspot.com

Adam Graetz

Adam Graetz draws his inspiration largely from the urban and suburban scenery in which he grew up. A perfectionist with an affinity for symmetry and patterns, Adam received his first SLR in 2003 (a Nikon N6006) after his sister decided to drop a photography class, and was instantly hooked. Today, he shoots mostly digital with a Nikon D7000, but also shoots film with a Nikon FM-2, preferring Fuji Superia for color and Kodak Trichrome for B&W. There's also the occasional Holga shot mixed in, or a Mamiya 645 for medium format. Travel plays a significant role in his work, and he always keeps his camera at the ready while exploring new territory.

Having recently graduated from UNC-Chapel Hill, where he studied media production and international relations, Adam enjoys design, filmmaking, audio production, and just about any digital media project he can get his hands on. He has also been teaching Adobe Creative Suite and Final Cut Studio on an individual basis for the past four years.

"The idea of man vs nature often comes up in my work. Sometimes I juxtapose evidence of human civilization against naturally occurring elements; other times I seek to completely remove any signs of civilization in my photos, to make them completely natural."

You can find out more about Adam at his website, www.adamgraetz.com and view his flickr photo gallery at www.flickr.com/photos/adamgee

Introduction

It's easy to underestimate the significance of light, as it's basically ubiquitous in our waking lives. If we aren't outside during the day being guided by the sun, we're constantly battling back the darkness with our own artificial lights. Even scenarios we consider quite dark will almost always have some source of light in them, like a path through the woods at night being ever so faintly illuminated by the moon above. As such, most people take light for granted. Either it's there or not; the lamp is turned either on or off. And if it's there, it's either bright or dim, simple as that.

Photographers, of course, know there's quite a lot more going on, and that's what makes light and lighting such an interesting and fundamental element of photography. Light is rather like our own photographic language, and becoming fluent in it is an essential step in building your repertoire of photographic skill. Photographers sometimes speak of their ability to "see" or "read" light. On the surface, this is a rather obvious statement; of course you can see light, everyone does. But what they are referring to is their particular ability to observe the fine and subtle qualities of light, then capture them and make them work creatively in an image. Photographers notice the color of different light sources, the density and length of shadows, the angles of light and corresponding times of day—the list goes on and on.

When it comes to making photographs, light is the single element that will always make a difference in the shot. A subject or scene may be boring or totally commonplace in one kind of light, but change the angle or intensity, and suddenly it's something more than it was before. Sometimes the light is so striking that it becomes the subject of the photograph itself. It's probably impossible to isolate precisely what kind of light is flattering or aesthetically pleasing and why (though there are general trends to look out for, such as the golden light at the beginning and end of the day); such universalities are hard to come by in art. But you will learn to recognize the exceptional qualities of light when you see them, and to make the most of those situations as you encounter them.

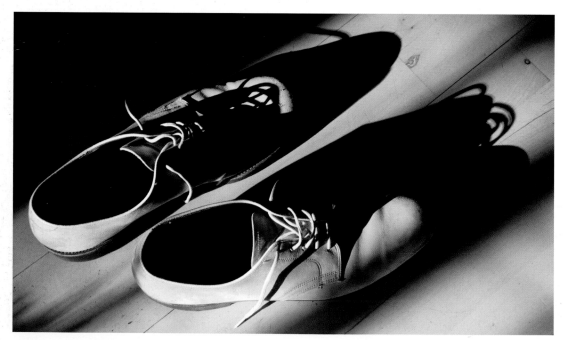

← Shoe shadows
An appreciation for the nuances of light and the dynamism that it can contribute to a photograph is absolutely invaluable. It opens up a whole world of potential images, sometimes in the places you least expect.

In most situations, there is usually some degree of control over the light, and thus corresponding decisions that have to be made in order to achieve the shot. But even in those photojournalistic or naturalistic situations where there's either no time or no desire to influence the light directly, you still have decisions to make as to how your camera responds to and records that light. How dense do you want your shadows? Do you need to preserve detail in the highlights? Should you color balance for the warm tungsten lights or the daylight coming through the window? Gradually, as you become fluent in the language of light, these questions will be less like obstacles to overcome, and more like creative tools you can use to achieve your particular vision.

→ **A fleeting moment**
Some scenes will immediately strike you for their unique lighting conditions. Such conditions are often fleeting—particularly if they are the result of natural light—so it is essential that you learn to recognize them instantly and capture them quickly.

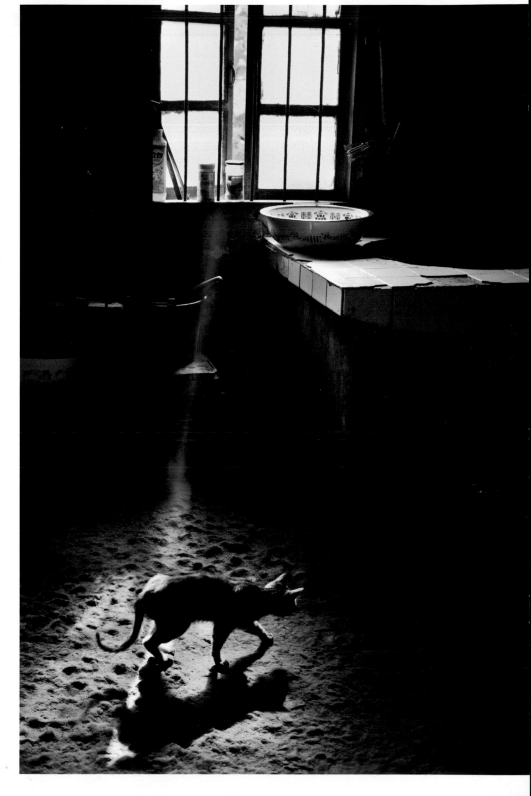

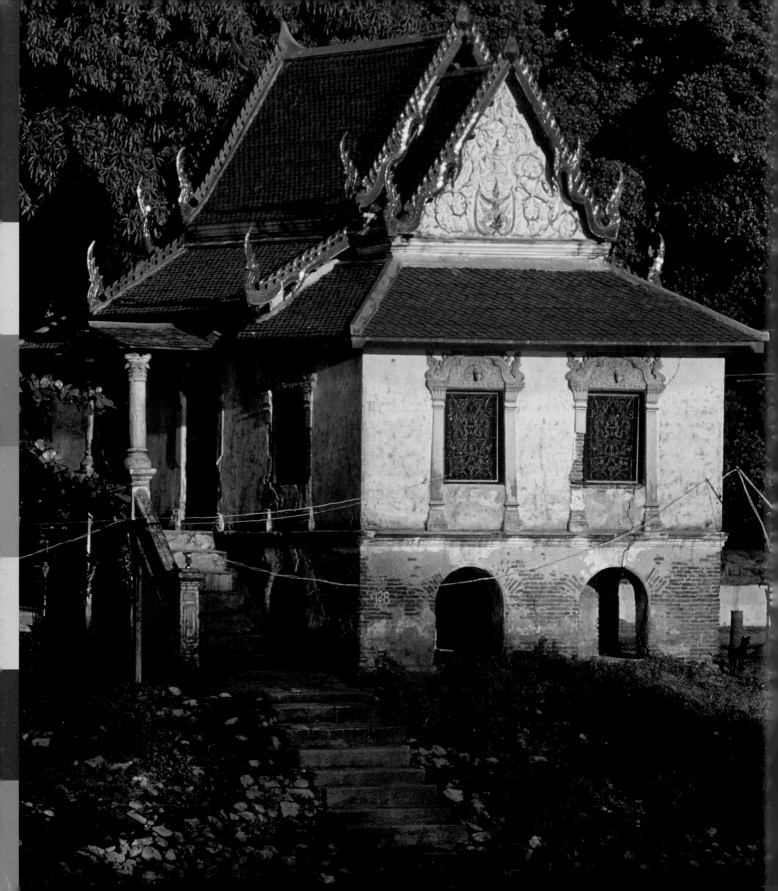

Lighting Fundamentals

Light is deceptively complex. It is testament to our highly evolved visual sensory system that we can walk from a bright, sunny day into a dim, tungsten-lit room and barely perceive a difference. Likewise, it is astounding that we can simultaneously see a bright blue sky and the details of shade cast by a tree in the same scene. It takes a trained eye to recognize what is remarkable about these innate gifts, and as you evolve as a photographer, you will gradually begin to see the subtle nuances of light in every part of your life.

Learning to "see" light will not only help you find engaging and compelling subjects to photograph, but also instruct you in how to capture those subjects with your digital camera. Camera sensors react to and record light in a way that is quite different from our perception, which involves interaction the eyes and brain. In addition to learning to appreciate your own eyesight, you must also learn to see the world as your camera sees it. This is all part of moving away from the convenient automation of digital technology and taking control of your photography.

Of course, your camera will meet you halfway, offering easy and instant control of all the variables you encounter. White balance can be adjusted on the fly, precise measurements can be taken, and complex exposure calculations can be crunched in the blink of an eye. Little by little, your camera will get out of the way, and you will intuitively know exactly what settings to use for any given lighting scenario. All of this begins with a thorough understanding of both light itself, and how your camera operates in its capture.

How Digital Cameras Record Light

In order to gain mastery of light and lighting in your photography, it is important to understand how your camera captures and processes that light when it creates an image file. At the heart of every digital camera is the imaging sensor: a silicon chip that converts analog light into digital information. The surface of the chip is an array embedded with millions of light-sensitive photodiodes, each of which acquires a charge when light falls on it. The charge corresponds to the intensity of the light—the brighter the light, the higher the charge. When the sensor records an image, each charge is converted to a digital value, and those millions of values are assembled, processed, and saved to memory as an image file.

Of course, it's more complicated than it sounds. To begin with, those photodiodes cannot directly capture any color information; they measure and record only monochrome light. Various engineering tricks must be applied to overcome this limitation and create color information out of purely monochrome data.

Color Filter Arrays

In most imaging sensors, a color filter is installed on top of each photodiode, effectively making it color-sensitive by letting it capture only one certain color. Some diodes are filtered for red, some for green, and some for blue (RGB); and these filters are arranged in a R-G-B-G pattern (the human eye is more sensitive to green light, so more diodes are dedicated to capturing green). Because these three primary colors can be combined to create almost any other color, the camera can then combine the information from four neighboring photodiodes to create a single unit of color information called a pixel.

As you might guess, the use of these Color Filter Arrays (CFAs) comes with some drawbacks. For one, the process by which the camera combines the separate RGB channels, called interpolation, is not always perfect. It is merely the image processor's best guess at what the original color was before it was divided among four separate photodiodes. However, the more information provided to the processor, the better the results appear. Fortunately, pixels are counted by the millions (one million pixels = 1 megapixel or MP).

← Getting the details
It takes millions of pixels to capture enough detail for an image to appear lifelike.

ISO Sensitivity

A significant advantage of using imaging sensors instead of film is the ability to dynamically change the sensor's sensitivity to light from shot to shot. This light sensitivity is called the ISO—referring to the International Organization for Standardization that created the standard. Lower ISOs are less sensitive to light, and higher ISOs are more sensitive. While it may seem sensible to always use as high a sensitivity to light as possible, these higher ISOs do not come without a price.

Sensors are calibrated to a base ISO, usually 100 or 200, at which the sensor delivers its maximum possible image quality. As the ISO is increased, the signal-to-noise ratio of the sensor output decreases, and the image quality is gradually degraded. This degradation is most apparent in the form of digital noise—a random pattern of bright and multicolored speckles that can be likened to the static hiss in the background of an audio track. Noise appears most obviously in dark to mid-tones that lack detail, and at its worst it can be so distracting that the important elements of the scene are difficult to see.

Today's digital cameras have made remarkable progress in eliminating much of this noise and delivering a clean image signal up through even relatively high ISOs like 1600 and 3200. Nevertheless, higher ISOs should be used only when absolutely necessary—in low light, for example; or for capturing fast-moving action. For the best color accuracy, the most dynamic range, and the cleanest textures, stick to your camera's base ISO.

↑ Hidden in the shadows
A high ISO sensitivity can result in digital noise, as seen here in the speckles in the darker areas of this image (made much more noticeable by boosting the exposure in a Raw developer). Note that another side effect of higher ISOs is a decrease in the sensor's dynamic range—discussed on the following page.

Raw vs JPEG

Most images you see are saved in a file format called JPEG, which stands for the Joint Photographic Experts Group that created the standard. When a digital camera creates a JPEG, it is already applying a whole series of processing adjustments, including contrast, sharpness, white balance, and so on. High-end compacts and digital SLRs, however, also allow you to save a file in a Raw format, in which none of these adjustments are made yet. The result is a file that must first be developed in a Raw processor, but which is much more malleable in post-production because it contains a greater amount of information to work with. For optimal quality, it is always best to shoot Raw.

Dynamic Range

In photographic terms, dynamic range is the difference between the brightest and the darkest tones of light. High-contrast scenes like a shady tree bathed in direct sunlight have a high dynamic range, because there is a large exposure difference between the shadows and the sky. In low-contrast scenes such as gray, overcast landscapes, most of the light is of the same intensity, and so the image has a relatively low dynamic range. Scenes with a high dynamic range are more difficult to capture, because even top-of-the-line sensor technology is only capable of capturing a limited dynamic range that often falls short of the full range of light. Knowing how to make best use of this sensor limitation is important to capturing quality images.

Imagine all the pixels on your camera's sensor as little buckets for collecting light. When the shutter is released, each bucket is filled with a varying level of light. Once the shutter closes, the fill level of each bucket is measured, usually between 0–255, with 0 being pure black and 255 being pure white. If a light bucket is filled up to 255 before the end of the exposure, it can't continue to measure any more light, and detail in that portion of the scene will be lost. Likewise, if not enough light struck a portion of the frame, those buckets will read 0 and detail will be lost in the shadows. The key to a successful exposure is getting most of the light to fall between these two extremes, thereby capturing detail from as much of the scene as possible. And remember that at high ISOs the shadows are the most affected by noise, which can overwhelm the real detail.

f-Stops

Dynamic range is measured in many ways, but the most useful for us photographers is in the units called f-stops. A sunlit scene may be composed of upward of 16 stops of dynamic range. The human eye can accommodate this wide range of light intensities by rapidly scanning local areas within the field of view, and then dynamically assembling theme into a complete picture in the visual cortex. Modern digital cameras, on the other hand, can capture only between 10–14 stops in a single exposure. Photographers must use a variety of techniques to capture scenes with dynamic ranges in excess of their camera's recording ability—beginning by calculating an optimal exposure.

↑ **High-contrast landscapes**
Here you can see detail in the foreground shadow and the surrounding landscape, but the sky is almost pure white. When there is too much dynamic range, a decision has to be made regarding where to place the exposure.

↓ **Filling up the buckets**
Thinking of light in quantitative amounts like water filling up a bucket is a useful way of understanding how your camera works with the dynamic range of a scene.

The Histogram

Digital cameras offer an invaluable tool for measuring the dynamic range of a scene: the luminance histogram. This chart maps the tonal values of a scene from pure black at the far left to pure white at the far right—on a scale from 0–255, corresponding to the fill levels of the pixels. If your camera has live view, you can get a real-time read-out of these values on the LCD screen as you compose your shot. Otherwise, you can take a shot, evaluate it in playback, and adjust your exposure settings as necessary. Images can also be viewed with a histogram in post-production using editing software such as Photoshop.

Using the histogram, photographers can rapidly identify potential exposure problems if the chart is distinctly out of balance. The goal is to have the histogram rise from the bottom left, gently sloping up and then down across the chart, ending at the bottom right. If most of the histogram is bunched up on the far left, the image will be underexposed—too dark with blocked-up shadows lacking any detail. If the slope is cut off at the far right, the image will be overexposed—too bright with clipped highlights.

The histogram can also display separate charts for each RGB color channel, giving you a better idea of which particular areas of the scene may be in danger of under- or overexposure. One channel may be clipped off in the highlights while the other two are properly captured. This means that there will be some detail in the highlights, but its color will not be accurate (as the processor is only getting two-thirds of the full color information).

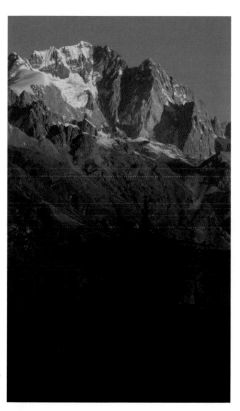

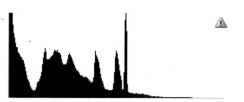

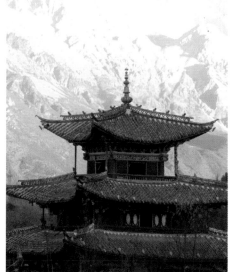

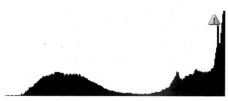

← Highlight detail (far left)
The long, flat line along the right side of the histogram indicates that there is plenty of information for the brightly lit mountains in the background. But the left side of the histogram is cut off at a spike, reflected in the shadowy silhouette of the temple in the foreground.

↖ Shadow detail (above left)
Here the exposure was adjusted toward the shadows, which are now a gentle slope along the left side of the histogram. But shifting the exposure pushed the highlights out of range, and the background is now completely lost in pure white.

Bit-Depth & Tonality

In digital imaging, each and every tone and color value is assigned a definite, discrete numerical value (as opposed to film, which exists in an analogue continuum). The basic unit for computing is called a "bit," short for "binary digit." These bits are either on or off, ones or zeroes, black or white—there is no in-between (hence the "binary" terminology). So a single bit could indicate that a pixel is either pure black or pure white, but that doesn't leave any room for the infinite gradations of gray in between these two extremes. To fill in the gaps, we can put a string of bits together and combine them to give us a greater number of intermediate values. If we put 8 bits together, that gives us 256 (2^8) discrete values in which we can store information. When applied to digital images, that range of values is called the "bit-depth" of the image.

Recall that on the previous pages, in our discussion of dynamic range, I mentioned that in the creation of an image file, the imaging sensor assigns a numerical value to each pixel, usually in a range from 0–255. Now you can see where that number comes from: The image file (in this case) is constructed using 8 bits. Now that may not seem like a lot; certainly we can perceive more than just 256 colors and shades in an image. But also recall that each pixel is interpolated out of the data from three different photodiodes, one per primary color. So in fact, a color channel contains 256 x 256 x 256 different levels of information, resulting in 16.7 million possible colors, far more than we are able to perceive with the human eye.

While 16.7 million colors may seem more than adequate for all our image needs, that is not always the case. Take, for instance, a wide-angled shot that contains a vast expanse of blue sky and a horizon line with some darker landscape at the bottom of the frame. As the sky approaches the horizon, its blue tones gradually get darker. The difference between the light and dark areas of the sky may not be very great, but it is stretched out across the majority of the frame. So rather than using 16.7 million discrete levels to illustrate this gradient, the image may use only a few dozen. The resulting image will probably exhibit a phenomenon called banding: obvious and perceptible jumps between tonal values across a large area of the frame. Even if it is not terribly obvious at first, any significant adjustments in post-production would exaggerate these abrupt jumps between tonal values, and the results would be distracting and unrealistic.

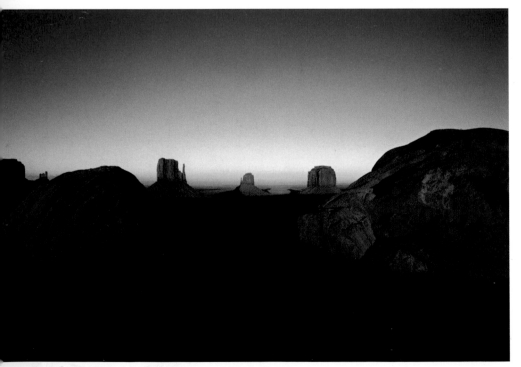

← Lots of skyline
The gradual lightening of the blue sky as it moves from the top of the frame toward the horizon is a large part of what makes this image work. Had the image not been saved with sufficient bit-depth, that delicate gradient could easily have appeared as a series of stripes across the sky, with obvious jumps across tonal values.

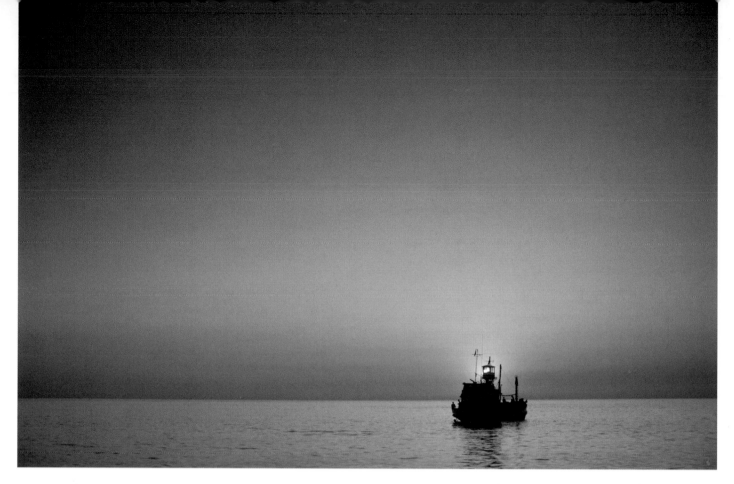

Increasing Bit-Depth

We can mitigate this banding effect by working in a greater bit-depth. The 8-bit format we've been discussing so far is just the base level for building digital image files—used by JPEGs, in-camera histograms, and most LCD displays. If you shoot in the Raw format, today's imaging sensors are capable of saving images in 12- or 14-bit formats. This gives you 65,536 discrete values per channel, or 281 trillion colors to work with—quite enough to protect even the most subtle of gradients from exhibiting banding.

Of course, Raw files must be processed before they can be displayed, and if you plan on manipulating them further in image-processing software, you should make sure that you continue to work in

a large enough bit-depth. In Photoshop, go to Image > Mode and make sure that either 16- or 32-bits/channel is selected. However, keep in mind that most displays and printers will still only use 8-bits per channel, so you will need to save the file back down before displaying or printing the image—but don't worry, you are still making use of the greater original bit-depth and range of tonality; you are just doing a better job of distributing that tonality across the areas of the frame that need it most.

It's worth noting that there is a clear distinction between dynamic range and bit-depth: While we can increase the number of discrete values into which a given range is divided, we are not actually expanding that range. Which is to say, working in greater bit-depths

↑ Plenty of Space
Not every scene requires a full 281 trillion colors in order to capture an accurate representation—and sometimes, if you are going for a high-contrast look, you'll be throwing out a lot of those in-between values anyway. The key is to recognize which scenes exhibit a large gradient that requires greater bit-depths and shoot accordingly. Of course, shooting in Raw is generally a good idea regardless, as you will always have the option to make use of the greater range of tonality if it's needed.

does not increase the dynamic range of the sensor—black is still black and white is still white. Rather, greater bit-depths simply give us more room to exhibit the differences between those extremes.

Color Temperature

Color depends a surprising amount on the psychology of human perception. We evolved to see in daylight, and its colorless white appearance is the standard by which we judge light from all other sources. Fire and candlelight are perceived to be reddish orange and warmer in tone, while shade is seen as cooler and blue. To categorize this spectrum of light from various sources, color is measured in degrees Kelvin and placed along a temperature scale from red, through white, to blue. Understanding this scale allows us to describe color in a meaningful way, and make precise adjustments to how that color is represented in a photograph.

The human eye is remarkably adaptable to these various colors of light, and is constantly adjusting to ensure that all colors in all lighting conditions are perceived as normal. Digital cameras are not so lucky, and must be properly calibrated to the light in a given scene in order to render accurate colors. This is particularly true considering the abundance of light from artificial sources such as fluorescent lights, which cast a broken spectrum with spikes of green that do not fall on the natural red-to-blue color scale.

The practical scale of color temperature

For photography, the important light sources for which color temperature has to be calculated range from domestic tungsten to blue skylight. Precision is difficult, particularly with daylight, because weather and sky conditions vary so much. There are also differences of opinion on what constitutes pure white sunlight.

K	Natural source	Artificial source
10,000	Blue sky	
7500	Shade under blue sky	
7000	Shade under partly cloudy sky	
6500	Daylight, deep shade	
6000	Overcast sky	Electronic flash
5200	Average noon daylight	Flash bulb
5000		
4500	Afternoon sunlight	Fluorescent "daylight"
4000		Fluorescent "warm light"
3500	Early morning/evening sunlight	Photofloods (3400K)
3000	Sunset	Photolamps/studio tungsten (3200K)
2500		Domestic tungsten
1930	Candlelight	

← **City at dusk**
The strong red-orange color cast in this cityscape affects the mood of the photo, and reflects the time of day at which it was shot.

White Balance

White subjects most closely reflect the color of their light source, and are therefore used as a reference point by assigning them to the brightest highlights, and then shifting all the other colors in the scene accordingly. This process is called setting the white balance (WB), and can be carried out in a number of different ways.

Digital cameras offer an Auto white balance feature that acts like the human eye, deciding what is white and setting a correspondingly neutral color cast on its own accord. In simple lighting conditions with natural light sources, Auto white balance often works quite well. In more challenging situations, it will be necessary for you to help the camera discern what is white and what isn't. Fortunately, you can always evaluate the color accuracy of a saved image in playback on your camera's LCD screen.

← Tube as recorded
In reality, this tube interior has a blueish cast; but because the human eye automatically adjusts for this in real-time, it appears unnatural in a photograph.

← Tube as remembered
Here we see the white balance adjustment makes the image appear more natural and removes the blue cast.

WB Presets

If you know the light source, you can directly indicate it to the camera by selecting its corresponding WB preset. These vary from camera to camera, but typically include (in increasing color temperature) Incandescent/Tungsten, Fluorescent, Sunlight, Flash, Cloudy, and Shade. The color temperatures used by these presets are just ballpark figures, as precise temperatures vary even among common light sources; but they can be useful if you are consistently shooting under a definitive light source. Most digital cameras also allow you to manually enter the precise color temperature in degrees Kelvin, which is useful in studio setups.

Custom White Balance

The most accurate method for deriving a scene's white balance is to manually indicate to the camera a neutral gray or white surface that is reflecting the same light as the picture to be taken. The camera saves the color temperature reflecting off that particular object, and applies it to the next shot. Gray cards are a useful tool for this method, especially considering that not every scene will contain a pure white or neutral gray surface. An 18% gray card is a totally neutral color that is first placed in a scene, then photographed, and finally assigned to a custom white balance. The card is then removed and the scene is rephotographed using the precise color temperature of the ambient light.

You can do something similar in post-production if you saved the original image in a Raw format. In this file format, the white balance has not yet been set, and you can manually apply one by clicking on a white or gray surface in the image on your computer screen. Raw formats give a great deal of flexibility, particularly in situations where multiple light sources are casting different color casts on a subject.

→ **Frigid blues**

It would have been easy to simply click on the frozen ice with the white balance dropper tool and render the entire scene a faithful white, but that would have lost the intensely cold feeling that a blue rendition gives the shot.

Challenge Checklist

→ Shoot Raw, so that you can tweak white balance settings in post-production with ease.

→ Pick a scene or subject with a consistent and definitive light source.

→ Don't go wild with your WB sliders, and don't pick a completely bizarre WB preset (i.e., fluorescent WB for a midday sunlight scene).

→ Stay somewhat within the appropriate range of accurate white balance, but experiment with a limited range of color temperatures on either side of what your camera deems accurate, and see if the results are worth keeping.

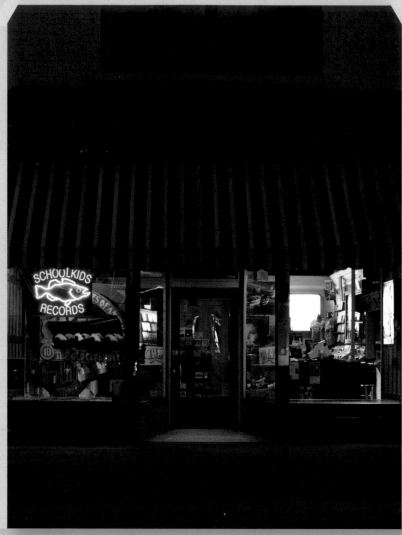

© Adam Graetz

With this shot, I set the white balance to Shade to fit it to the blues around the window front, while also maintaining the beautiful yellow glow of the incandescent lights in the record shop.
Adam Graetz

The blue color cast above the awning (also not a neutral rendering) complements the yellow tungsten quite well. It feels like a street scene should feel, and is a good case for not always using a perfect, technically accurate white balance.
Michael Freeman

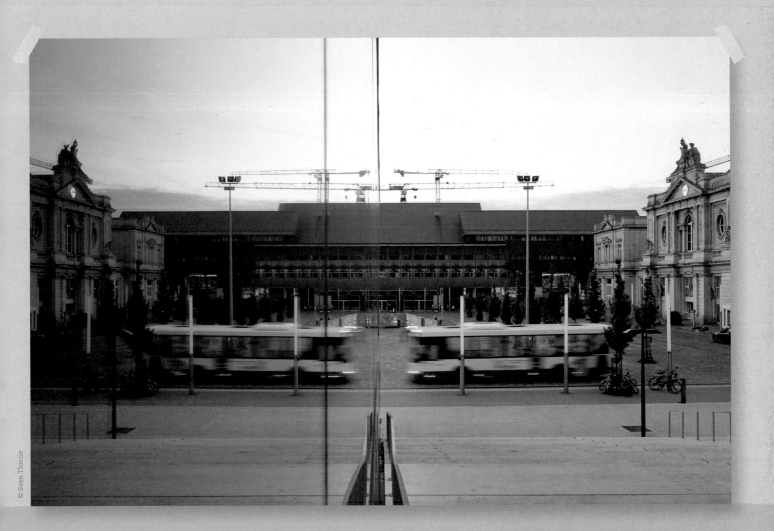

© Sven Thierie

The sun was setting and my original auto white balance reading was quite warm, but it wasn't quite how I wanted to interpret the scene. Rather than warm and inviting, I wanted this mostly empty city square to feel colder and more fleeting; so I brought the color temperature down quite a bit.
Sven Thierie

It does end up feeling colder and a bit stranger as a result—which rather suits the physical impossibility of the mirror-image scene. It's not a "straight" portrayal, compositionally, so it makes sense that the color balance should be likewise interpretive and creative.
Michael Freeman

Measuring Light

Light must be measured before it can be used creatively, and over time you will learn to "read" the light before ever bringing the camera to your eye. You can build this expertise in a practical way by making use of a light meter—a tool for numerically quantifying the intensity of light reflecting off or falling on a given area. These are built into digital cameras, wherein they measure through-the-lens (TTL) the light reflecting off a framed scene. Separate, handheld meters are also available, and work by directly measuring the light falling on a subject.

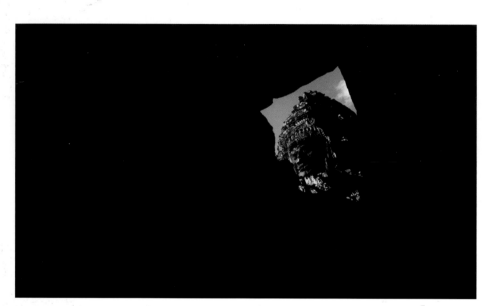

← Framing with Shadows
Only the spot-metering area could fit through this small opening in the temple of Bayon in Angkor, Cambodia to fall on the daylit statue outside. It wasn't important that the darker interior be captured at all (the massive dynamic range would have made that impossible in any case), so it is allowed to fall into shadow, to further emphasize and frame the exterior area.

Handheld Meter

A professional hand-held light meter, fitted with a diffusing dome like this, allows for more precise measurements by measuring the light falling on the scene (known as an incident reading) rather than the light reflected from the scene (as with built-in meters).

Using your Camera's Built-in Light Meter

Light meters built into digital cameras are an essential and advanced tool, but they are not a silver bullet; it is up to the photographer to use the meter appropriately for a given scene, and to interpret its measurements accurately. This is relatively easy with evenly-lit scenes wherein all parts of the frame are reflecting the same general amount of light. Many scenes, however, are more complicated, being composed of varying elements, each of which requires its own particular exposure. While the metering systems in digital cameras vary in their sophistication, they generally all have three distinct modes of operation, each optimized for particular lighting conditions.

Metering with your camera is as simple as choosing an automatic mode and taking a picture. Reflected light is measured from various areas of the framed scene, and the camera sets a corresponding ISO/shutter speed/aperture (depending on the exposure mode in use). Even in Manual mode, digital cameras will still meter the scene, displaying those measurements as a guide for your exposure settings.

Matrix

This metering mode goes by many different names depending on the camera manufacturer—Multi-Zone, Evaluative, Electro-Selective Pattern (ESP), etc.—but they all work according to the same principle. A framed scene is divided into multiple segments, each of which is metered separately. The system then calculates an average exposure for the composite scene by comparing its readings to an image library programmed in its memory (consisting of some 30,000+ images in the case of Nikon). It may even take into account focusing information, giving exposure preference to the area of sharpest focus.

Center-Weighted

Center-weighted metering mode still measures the full scene, but gives exposure preference to a circle in the central zone of the frame—the general idea being that what is in the center of the frame is more important than the elements around the edges. The precise weight that this center circle is given depends on your particular camera model, and some models allow you to adjust the degree of exposure preference and size of the circle.

Spot

Spot metering measures the light only within a tiny circle that may cover as little as 2% of the total frame, and completely ignores everything outside of that circle. It is used for precise measurements in complex lighting conditions, and the circle can often be placed anywhere in the frame.

↑ Straightforward scene
In this image, the camera's Matrix metering system recognized the highlights at the top of the frame to be a blue sky, and adjusted the exposure to ensure its successful capture.

↓ More challenging lighting
The tops of these trees, surrounded by shadows around the edges of the frame, needed center-weighted metering to properly ignore the much darker shadows without also overexposing the sky.

Challenge

Limit Yourself to Spot Metering

As a specialized tool for specific lighting situations, spot metering will give you excellent insight into how your camera's metering system works. Whereas matrix and center-weighted modes are often the camera's defaults, and are generally suited to a wide variety of scenes, spot metering requires a more considered approach, and makes you carefully evaluate the scene yourself, rather than relying entirely on the camera. It depends, as you might expect, on your having enough time and a fairly static subject.

For this challenge, all you have to do is use spot metering to properly expose a scene. That may mean you shoot a spot-lit subject, allowing only the subject itself to be exposed while the surroundings fall off into shadow; or you can use it for a complicated scene with a variety of light levels, in which case you should meter off of what you deem to be a mid-toned area of the frame, allowing the highlights and shadows to fall accordingly.

→ **High-dynamic garden**
Matrix metering was underexposing the bottom left part of this frame in order to capture all the detail in the garden. By spot metering off the rock garden directly, I was able to strike a nice balance with the exposure.

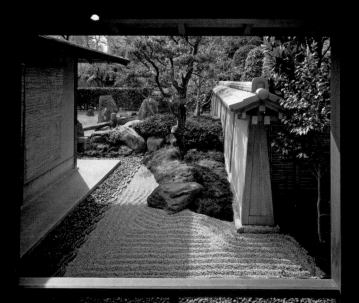

→ **Cockpit view**

Spot metering will let you drop off large portions of your frame into shadow—if that suits your particular shot. The results can often be quite dramatic.

Challenge Checklist

→ As you move the spot metering area across a scene, you will see your exposure settings vary wildly as it passes from shadows to highlights. The key is to recognize these extremes of exposure, and either indulge in one or the other for a high- or low-key shot, or select a happy medium in between the extremes (and that will be the mid-tones).

→ Green grass is an excellent mid-toned subject that can often be used to set the exposure for a larger scene. Just spot meter off some grass that is lit by the same light as the rest of the scene, and the results should be a good balance between shadows and highlights.

→ Use autoexposure lock [AEL] to keep the spot-metered exposure held in the camera while you recompose the shot to your liking.

Review

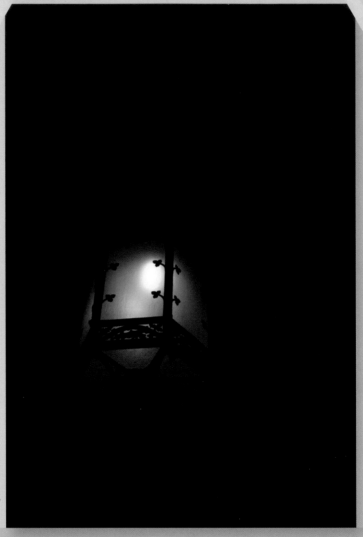

© Kelly Jo Garner

St. Anthony Hall, on the campus of Yale University, has these fantastic light covers that just glow magnificently in the dark. I bracketed my shots but eventually wound up liking this stopped-down one the best.
Kelly Jo Garner

One could hardly ask for a better illustration of spot metering, both in practical terms, in that clearly only a small area of the frame (the lamp) was metered, and also in terms of why spot metering is useful: The pure black surrounding the lamp is evocative and engaging, giving the photo an eerie mood.
Michael Freeman

For this photograph I used the only available light, which was the light inside the glass terrarium. This made for a long exposure since flash would only bounce off the glass. The camera was steadied against a wall for stability.

Jennifer Laughlin

This image does a good job of demonstrating the usefulness of spot metering in difficult lighting conditions. Because the light levels were so low, it was wise to meter only off the subject itself and not bother with the unimportant background elements that might otherwise have demanded a longer shutter speed.

Michael Freeman

Daylight

Most people think of daylight as a constant lighting condition from dawn to dusk. Sun in the sky? Daylight. Photographers, on the other hand, know that daylight is considerably more nuanced than that, and comes with almost infinite variables and representations. Depending on the angle of the sun in the sky, weather, cloud cover, even time of the year, the intensity of that daylight will deliver markedly different results. The skilled photographer must understand how these changing conditions can be used to maximum effect.

Imagine an outdoor scene as a giant, domed studio, lit by a single spotlight. By waiting for the right time of day, you can control the angle of that light on your subject. And by using existing cloud cover and weather conditions, that light can be diffused or reflected in any number of ways. Thinking about an outdoor scene in these studio terms can help prevent daylight from becoming an uncompromising, intimidating lighting condition over which you have no control. Just because a scene is lit a certain way at a certain time of day—or even in a certain season of the year—doesn't mean that is the only way it can be photographed. Try moving to a different position, waiting for clouds to arrive or pass, or even directly manipulating the light with your own diffusers, reflectors, or lens filters.

Amid all the various positions and durations of sunlight, there is only one essential question: What is the most flattering daylight possible for my subject? Once you know that, it is simply a matter of employing the right techniques and equipment to capture the shot as you want to see it.

The Sun Throughout the Day

The time of the day will be the most important factor contributing to the role of sunlight in your photography. Sunlight shines at a very low angle early and late in the day, gradually rising to a harsh, high-angled light around noon (depending on Daylight Saving Time, of course).

↓ Sunset silhouettes
Sunsets are a traditional favorite time for photography, but as a subject in itself, a sunset alone can be rather commonplace. Using the brilliant lighting conditions of dusk as a backdrop for another subject, however, allows you to flex your creative muscle. Here, the brilliant skyline is reflected in a lake, casting the lone boat and tree line in a moody silhouette.

Dawn and Dusk

If you've ever raced against time to a scenic vista in order to view a sunset, you know how quickly light can change as the sun approaches the horizon. The movement of the sun, while barely perceptible across the vast expanse of a full sky, seems expedited at the beginning and end of the day. In reality, the sun moves at a constant speed, of course; it is merely the stationary reference point of the horizon line that lets us perceive its motion. But the quality of its light does indeed change rapidly, affected by the extreme angle at which it is shining on a scene. These changes can be unpredictable and dramatic, and you must work quickly to observe their effects and make use of them.

The sun appears red at the beginning and end of the day because its light is passing through more atmosphere, which scatters the blue and violet wavelengths. Additionally, any clouds that are present along the horizon have a farther distance to travel before they get out of the way, so there is a greater likelihood that red sunlight will be diffused through radiant, fiery cloudscapes.

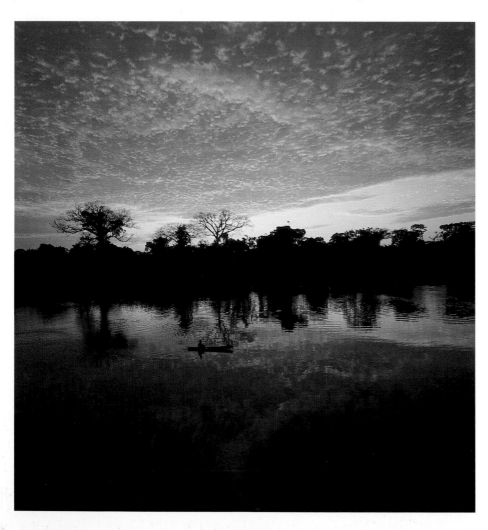

Midday Sun

At noon, the sun reaches its zenith and is at its brightest intensity. It is also at its most perpendicular angle to the earth, and so the shadows it casts are particularly harsh, creating high-contrast exposure situations. Delicate metering is essential in order to capture the full dynamic range of such scenes. In landscapes, various filters can help capture the high-intensity blue of the sky while still preserving the mid-toned greens of rolling hills and shadows cast by trees or buildings. Portraits can be particularly challenging, as the direction of this sunlight casts unflattering shadows down on a subject's face. These shadows can be filled in by flash or reflectors, or mitigated by diffusers.

On the other hand, if you embrace the contrast, midday sun can create punchy, dynamic images. Black-and-white photography is particularly suited to such conditions, as shadows and highlights are often expected to lack detail and be rendered pure black or white, respectively. But embracing high contrast usually means accepting and composing with dense, featureless shadows.

The Space Between

Recognizing the particular challenges presented by the extremes of light throughout the day, it follows that the light in between these times, during mid-morning and afternoon, is often easier to photograph. Not too high and not too low, this sunlight is perceived by the human eye to be both attractive (good for a variety of subjects) and neutral white (making white balance adjustment a simple matter).

← Strong contrasts
Black-and-white photography invites the use of strong contrast, and harsh shadows can be a compelling element of the composition, even if detail is lost in them.

↓ Mid-morning
Mid-morning sun is neutral enough to let subjects stand on their own. Here, the light is not so bright as to overwhelm the delicate yellows and greens in the trees, nor so angular as to make the shadows a major part of the composition.

Challenge

Shoot Under
the Midday Sun

↓ **Ornamental shadows**
The hard light of the midday sun is ideal for showing off the fine detail in elaborate architecture—where each element of ornamentation is cast in sharp relief and given depth by strong shadows.

Odds are you already have a good selection of images that suit this challenge residing in your photo library. It makes sense that a great many photos are taken under the midday sun, as this is when we are out-and-about the most. Events and social gatherings are often scheduled for the middle of the day out of simple convenience, and beyond that, it's the easiest time that you can go out for a photo walk yourself and take in the surroundings, keeping an eye out for engaging shots. For this challenge, you don't have to fight the sunlight; rather, just keep an eye out for its effects as it brilliantly illuminates various scenes and subjects, and see if you can compose the shot such that strong shadows are not dominating the frame. Or if they do, use these shadows as strong black shapes to help the composition.

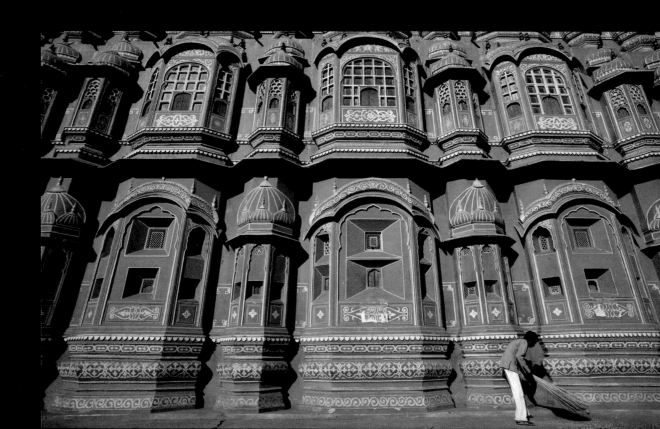

→ Busy at work
Direct sunlight will accentuate texture and introduce all sorts of graphic, angular shadows into your photography. Properly composed, these elements can greatly augment your shot.

Challenge Checklist

→ You will probably need to stop down the lens from its maximum aperture in order to avoid overexposure (so don't go for the super-shallow-depth-of-field shots).

→ If you want to add some saturation to the sky, you can always mount a polarizer on the end of your lens.

→ As always, watch your histograms and try to keep as much detail in the shadows as highlights as you can—recognizing that this is a high-contrast scenario and you may choose to sacrifice one or the other as you see fit.

Review

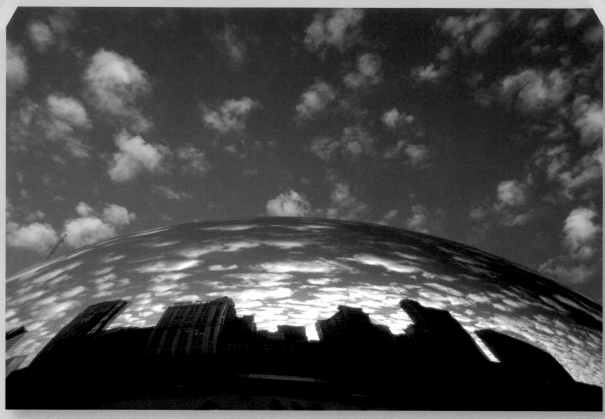

© Adam Graetz

I shot this one in Chicago using
an 18mm on a bright sunny day.
I exposed for the blues of the sky
thus to get a deeper color there
and maintain the silhouettes
of the buildings behind me.
Adam Graetz

A brilliant example of just how
stunning a bright blue sky can be.
Obviously the reflective sculpture
is also an excellent compositional
element, but it works because it
complements the sky, curving it
and making it seem even more
vast than it already is.
Michael Freeman

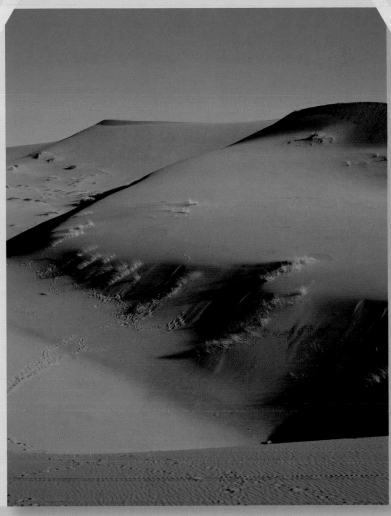

© Sven Thierie

There was no escaping the strong sunlight out in the desert, and everywhere I pointed the camera, the rich oranges of the dunes complemented the clear blue sky. I added some saturation in post-production to accentuate this look.

Sven Thierie

The strong shadows cast by the midday sun help sculpt the contours of these desert dunes and gives them shape. This is useful, as the dunes themselves lack detail and need those shadows to give depth to the image. The more flatly lit foreground, however, may not be contributing very much to the shot, and you might consider a tighter crop.

Michael Freeman

Dealing with Strong Sunlight

It is all well and good to speak of the patience required for photographing a scene in ideal sunlight, but as a photographer, you are not completely at the mercy of nature. On the contrary, you possess a variety of tools and techniques to manipulate the light given to you so that it is optimal for any given subject.

Graduated Filters

In many landscape shots, the top of the frame is dominated by an extremely bright skyline, which is much brighter than the mid-tones and shadows occupying the bottom half of the frame. To squeeze all this dynamic range onto your camera's sensor, you can use a graduated (grad) filter to block some of the brightest light at the top, while allowing progressively more light to pass through as it moves down the frame. The most common is a neutral density filter, which blocks a certain amount of light without adding any color cast. Typically, you can slide these filters up and down within a holder mounted on the end of your lens, in order to line up the gradation level appropriately with the horizon of your scene. The effect can be readily observed in the histogram: As the filter slides down over the lens, the right side of the histogram will gradually approach the right edge. The goal is to get the highlights as close to this right-side edge as possible without clipping them off.

↓ Filter effects

Grad filters help balance bright skies against shadowed foregrounds, and can also be used to add a color cast. This composite image shows the effects of various grad filters, from left to right: no filter, neutral density, blue, and yellow. Much more cloud detail is captured with filters.

Polarizers

Another method of blocking some of the light in a scene in order to prevent overexposure is the use of a circular polarizing filter. These filters will darken skies and make clouds pop, and are most effective at right angles to the sun. By rotating the filter on the end of your lens, you can adjust the effect of the polarizer to suit your particular exposure situation. Be sure to pay attention to the other effects it has on your scene, as polarizers also reduce reflections from glass and water, and cut through atmospheric haze.

↓ Saturated skies

A polarizing filter makes the clouds pop against a vivid blue sky, and also keeps bright sunlight from reflecting off the water. Note that the wide-angle lens means the intensity of the polarizing effect varies across the frame, with the blue sky getting progressively more saturated toward the upper-left corner.

© Andre Nantel

← **Rounding out the light**
The light shining on this beach scene was strongly directional, so a collapsible silver-fabric reflector was used from off-camera right to fill in the shadows on the backs of these painted stone objects (by artist Yukako Shibata).

Filling in Shadows

Whereas neutral density and polarizing filters mitigate high-contrast lighting conditions by decreasing the intensity of the highlights, another option is to increase the intensity of the shadows and bring them closer to the highlights. This is called "filling in" the shadows, and can be accomplished in several ways. First, you can fire a flash and directly add light to the scene. This use of fill flash is effective, as the color temperature of flash is close enough to daylight that the two can usually be mixed without looking unnatural. However, it takes a delicate touch to balance the amount of fill flash with the ambient light—fully discussed on page 94.

Reflectors

At its simplest, a reflector is any surface that can bounce daylight onto a subject. You can direct where the reflected light falls by adjusting the angle of the reflector. White reflectors bounce the most light and are therefore the most common, though golden and silver reflectors can also be used if you want to add a particular color to your subject. By allowing you to directly observe their effects in real time before the shot is taken, reflectors can be much easier to use than fill flash. Lightweight and cheap, most reflectors also collapse for easy storage, making them an essential piece of equipment.

Diffusers

A diffuser is anything that scatters light from a given source such that it falls more evenly across a subject. In outdoor portraiture, for instance, positioning a large, semi-transparent panel in between the sun and your subject will distribute the sun's light evenly across their face, lifting shadows and toning down highlights.

← **Natural diffusers**
This portrait uses the natural diffusion of light through a bamboo forest to soften the shadows cast on the subject's face. The single streak of direct sunlight also adds dimensionality and ambience—but needs to be delicately color corrected in relation to the rest of the face, lest the subject appear too blue (from the color temperature of the shade).

Challenge

Tackle the Shadows

↓ Soft light, soft subject
In order to capture this shot of a kitten frolicking in a bright, outdoor scene, a diffuser was positioned just above to soften the harsh, direct sunlight and avoid unwanted shadows.

With all that you know about how direct sunlight creates challenging lighting conditions, you may be inclined to just avoid this difficult light source altogether—but then you'd be missing out on some of the most dramatic lighting available, not to mention eliminating a large part of the day when you should be out shooting! Fortunately. there are numerous ways to grabble with direct sunlight and its resulting shadows, and that's the point of this challenge.

If you're shooting portraits, equip yourself with a reflector or diffuser to either fill in shadows or diffuse the light before it ever reaches the subject. You might also simply try positioning your subject in the already diffuse shade of a tree, using the surroundings as a natural diffuser and avoiding shadows altogether. Finally, if your photo is properly exposed in the first place, and especially if it is saved in a Raw format, then lifting shadows in post-production might be a simple option.

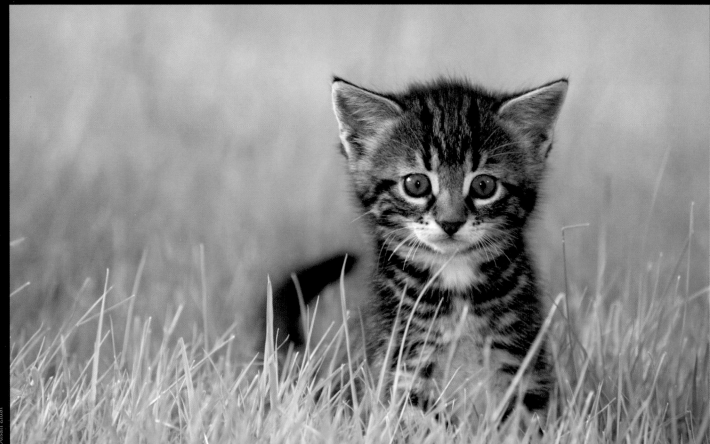

→ Natural shade

The subject is positioned in a naturally shady spot to decrease the obvious shadows from a somewhat low-angled sun. There's a bit of a color temperature difference between the warmer, sunnier right and cooler, shady left sides of the portrait, but not one so great as to be overly distracting.

Challenge Checklist

→ Begin by deciding exactly which areas of the frame need to hold detail, and see if there are any shadows that you don't mind being underexposed.

→ Matrix metering might give you the best average of the scene, but be ready to add some exposure compensation as you see fit, always keeping one eye on the histogram to ensure an optimal exposure.

→ If the shadows occupy a large portion of the frame, you'll just need to make a global exposure adjustment, either in-camera with positive exposure compensation, or in post-production by lifting the shadows. But if the shadows are localized, break out your diffusers, reflectors, and/or fill flash to fix it on the spot.

Review

© Kelly Jo Garner

After a heavy afternoon rain in Nashville, Tennessee, I looked out my front door and was instantly drawn to three hard stripes of color. I grabbed my camera before the sun ducked behind the clouds again, and got this shot.

Kelly Jo Garner

Although it's a little minimalist for my taste (perhaps a definite subject might have contributed had it been available), this shows observation and use of viewpoint and framing to create a study of shadows. Dividing the bands into thirds, like a triptych on its side, makes sense. It's good to react quickly to changing light!

Michael Freeman

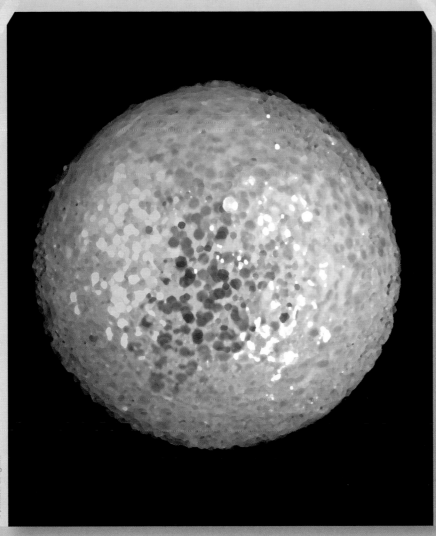

© Jennifer Laughlin

This photograph was taken indoors using a black sheet and one hot light placed slightly above the camera. I placed the subject against the black sheet, and I set up several reflectors to achieve the even lighting without shadow.
Jennifer Laughlin

With the even lighting all around this spherical object, it appears to float effortlessly against its backdrop. This does a good job of illustrating the usefulness for eliminating shadows in still-life photography.
Michael Freeman

Shooting into the Sun

Pointing your camera at the sun for a shot is a condition that excellently marks the difference between the science and art of photography. Technically, everything about this shooting scenario is wrong: Images strongly tend toward overexposure, color detail is easily lost, and textures are rendered flat. But creative and delicate manipulation of these conditions can deliver some of the most atmospheric and successful images.

Skilled manipulation of manual camera settings are vital when shooting into the sunlight. If the sun is visible in the frame, the extremely high dynamic range will mean you have to make a judgement call as to exposure—either your subject will be illuminated and your skies will be blown out to pure white, or your skies will be properly exposed around a shadowed, silhouetted foreground. Matrix metering will tend to assume overexposure and overcompensate by making the whole image too dark. Spot metering, on the other hand, lets you precisely indicate which area of the frame will be properly exposed. In any case, delicate use of the histogram is essential to achieving the look you want.

If you frame the shot such that the sun is masked by an element in the scene, that element (which will likely be underexposed and appear as a silhouette) will be framed in a light radiating out from its edges. This edge or "rim" lighting accentuates the shape of that element and lends a strong graphic emphasis to the image.

Shooting into the sun is technically known as backlighting, although unlike in a studio, the height of the backlight is chosen for you by the position of the sun. For this reason, many outdoor backlit shots are taken at dawn or dusk when the sun is at its lowest. At other times of day the photographer can lay on the ground and shoot at an upward angle in order to backlight a subject.

↓ Runway at dawn
Peaking through a gap in this airplane fin, the sun is given a definite shape that would otherwise be lost in overexposure. The underexposed, angular shape in the foreground becomes a strong graphic element, keeping the scene from being just another sunset photograph.

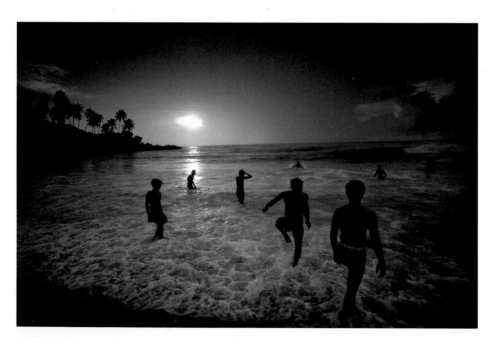

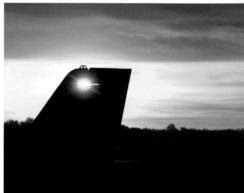

© Frank Gallaugher

← Facing dusk
Allowing these subjects to be cast as underexposed silhouettes greatly enhances the mood of this image, and means the distant sky can fit into the exposure and contribute to the atmosphere.

Flare

Any time you shoot into the sun, you are inviting excess light to be reflected off the many interior surfaces of your lens, creating streaks and artefacts known as flare. The wider the aperture used, the more prone to flare the resulting image will be. You can mount a lens hood on the end of your lens to help mitigate the presence of flare by shading the edges of the frame and keeping light from striking the front lens element at too extreme an angle. The hood itself is often lined with nonreflective material such as black felt, and can be either bowl or petal-shaped—the latter taking into account your sensor's aspect ratio. However, no lens hood is perfect, and even the best ones have little effect when the sun is directly in frame. Post-production will give you the opportunity to manually remove small amounts of flare, depending on how prevalent it is in the final image.

Creative Use of Flare

Technically, flare is an aberration—an error in the way a lens renders the light of a particular scene. But judicious and intentional use of flare can deliver some very pleasing effects. In particular, flare can work well to add a cinematic quality to a shot. The difficulty is that it is impossible to judge how images will turn out until they have been taken, and often the frame will be so bright it can be difficult to compose the shot. A useful technique is to shield a portion of the lens with your hand, adjust your composition and focus to your liking, then take your hand away before firing the shutter.

Proper Equipment

In addition to improving image quality and preventing unwanted flare, lens hoods can also protect the front lens element from bumps and scrapes.

↑ **Pentagonal flare**
The impromptu still-life makes use of strong backlit colors, but the line of flare artifacts (pentagonal from the aperture shape inside the lens), instead of being a problem, add to the graphics and colors, particularly because they occupy a central diagonal.

Face the Sun Head-On

This challenge will help you come to grips with the full potential of direct sunlight. You'll be shooting directly into the sun, but carefully setting up the shot to prevent total overexposure. The easiest way to achieve this is to block the sun by positioning some element in between it and your camera. The object will be rendered as a silhouette, but the rest of the scene will still be able to hold detail.

What metering mode is appropriate will depend on your particular scene, but in any case, you will need to keep a close eye on your histogram and be ready to override any autoexposure readings with exposure compensation in order to make sure the camera records the scene as you want it to. Positioning is also key, especially if you plan on blocking the sun—as you must both line up some object in the sun's light path, while also making sure the rest of the frame has an interesting composition. Scouting ahead of time will help, as you won't have very much time to set up your shot before the sun moves to a new position.

→ Flare for effect

Polygon stripes are hard to avoid if you shoot straight into a bright sun, but they can be made to work. Remember that they spread out from the light source in a line, so positioning the sun here in the top corner made them run diagonally into the frame, making them distinct and, by implication, deliberate. From one point of view, we're all so used to seeing flare that it's no longer a mistake, but something to help the mood—and in Hollywood special effects, flare is often added artificially for just that reason.

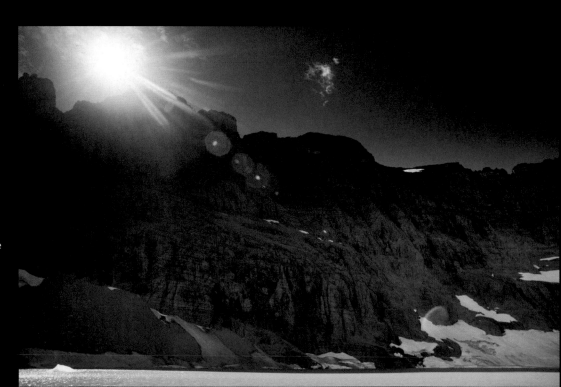

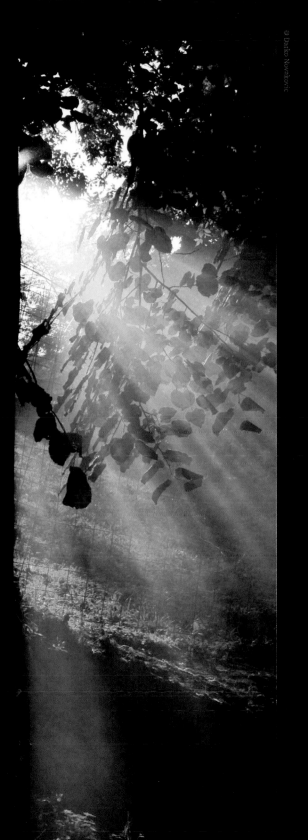

→ Radiant mist

Note that while they appear similar, these radiant beams of light are not flare artefacts, but rather ambient fog that is catching part of the light as the sun beams through it. By hiding the sun's actual disc behind the tree trunk, more of the tonal range of the beams has been captured, and there is less highlight clipping.

Challenge Checklist

- → If you have one, mount a lens hood to limit flare and help you see the frame as you are composing.

- → If you are completely unable to avoid flare in your shot, don't fight it—embrace the flare as a compositional element in itself and work with it, without allowing it to completely obscure other important elements.

- → Check your histogram after each shot and make sure your shadows and highlights aren't getting unintentionally clipped.

Review

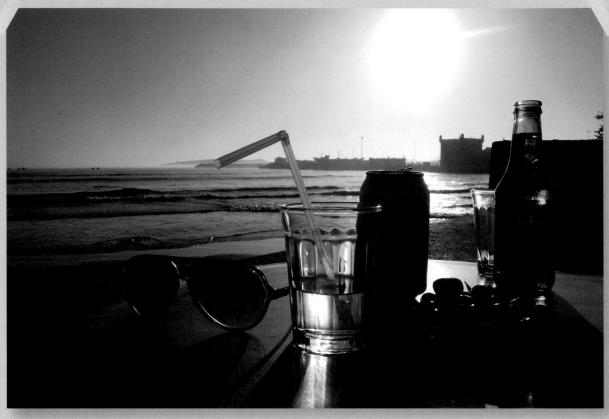

© Sven Thierie

The sunglasses, water glass, and bottle were all transparent, and casting interesting shadows across the table, and with the sun in the background this was an easy shot to set up—I ended up adjusting the color temperature as well to mimic the scene as I saw it through magenta-tinted sunglasses at the time.
Sven Thierie

Keeping the sunglasses in the composition was a nice touch—sort of a clue to the viewer as to the interpretive meaning of the color cast.
Michael Freeman

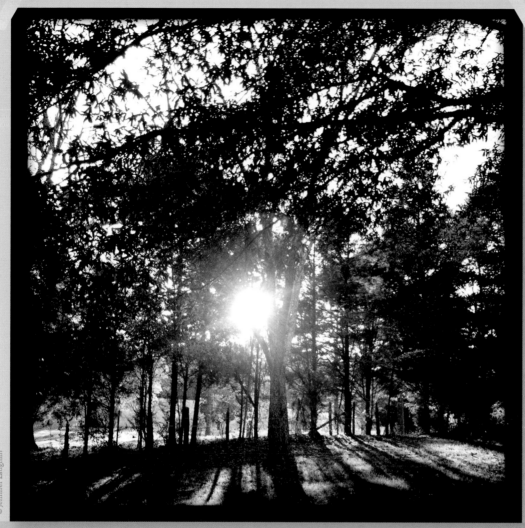

© Jennifer Laughlin

Shot as the sun set through the trees, whose long shadows are what originally caught my eye. I chose to shoot straight into the sun to create flare.
Jennifer Laughlin

A nice balance of exposure between capturing a glow from the sun that actually *feels* like looking into it, with visible shadow detail in the grass. Black and white also does a good job of making the viewer concentrate on the shadows and tonality.
Michael Freeman

Golden Light

© Frank Gallaugher

As discussed on page 36, the brief period of time when the sun is just above the horizon but still below about 20 degrees offers a distinctly warm, golden color of light—typically between 3500K and 4500K. The richness and saturation of the resulting colors, combined with long shadows cast by such a low-angled sun, create a signature look that is much beloved by photographers. Indeed, golden light is so popular that it almost risks becoming a cliché; and if your intention is to deliver images that are unique and distinguished, it may not be your first choice. But it is nevertheless an essential part of your photographic repertoire, and a safe bet for getting a memorable image.

Because we are accustomed to seeing the world this way for only a brief period of time each day, golden light imparts a sense of ephemerality and meaningfulness to a scene. Accordingly, you must work quick to make the most of this light, which usually lasts for only an hour at the beginning and end of the day. Scouting locations and planning your composition ahead of time ensures you can concentrate on tackling whatever exposure scenario this light presents.

↑ Urban reflections
Frontal golden light brings out rich, saturated colors, and the windows of this New York high-rise reflect the shimmering blue of a clear sky above.

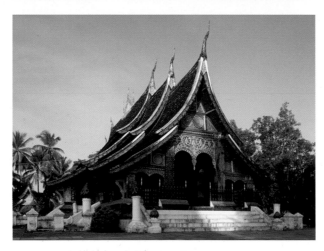

→ Laotian temple
Golden light communicates a sense of majesty, and is well suited to many architectural subjects. In this shot of a Laotian temple, the golden light serves its purpose without having to cover the entire building; the shadows speak to the surrounding environment and prevent the photograph from being a cliché.

The Three-Angle Choice

In addition to its flattering tonality, golden light is also beloved by photographers for the variety of angles it offers for any given subject. While the low angle of the sun stays constant, you can control how that light strikes your subject by moving the camera to various positions. As discussed on page 48, shooting into the sun creates a backlit scenario, with opportunities for silhouettes or edge-lit portraits. In backlit shots, shadows dominate the frame, such that very few directly illuminated areas are available to give the image any local contrast, resulting in the loss of fine detail.

If you turn completely around and shoot away from the sun, you have full frontal light that brilliantly reflects the natural colors of your subject, giving it an intense, grandiose appearance. Shadows get tricky with this angle, however, as your own shadow is now falling in toward the scene. This may not be an issue with a telephoto shot, but if you are shooting with a wide-angle lens, you may need to either carefully compose the scene so that your shadow is kept out of frame, or blend your shadow into the existing shade cast by some other element—a tall tree or building, perhaps.

Additionally, if your subject is framed such that you cannot see its shadows at all, the frontal light can sometimes make your image appear flat, as it doesn't offer the viewer any reference for the subject's depth.

In the interim 180 degrees between backlighting and frontal light, you have a plethora of side lighting options. This angle of light exaggerates depth and is defined by the long, horizontal shadows crossing the frame. The resulting high levels of contrast create ideal conditions for revealing fine texture in surfaces.

← Parisian post
Close-up shots with strong side lighting make the surface texture obvious and tangible, and shadows running horizontally across the frame lend a graphic quality.

← Suitably majestic
The long telephoto focal length means that, without strong shadows cast by this black-winged kite to anchor it to a particular environment, this shot feels like it is hovering in space—particularly suitable for its avian subject.

© Bernd Zoller

Challenge

Take Advantage of Golden Light

↓ Early risers

Getting up early enough for golden light shots means you often see a hidden side to a city or community—namely, the early risers that set everything in motion each morning. If you are traveling, this can be an excellent time to go exploring.

This challenge is all about timing—and if you want to double your opportunities, you may have to get out of bed and set up a shot quite early! The first and last hours of the day give such a unique color cast that it can be hard to hone in on a single subject, taking the time to find the optimal position and pose.

At the same time, of course, you are given an abundance of subjects that may otherwise seem commonplace and dull, but take on a new and stunning quality when bathed in golden light—so if something unexpected does catch your eye, work fast and see what kind of shots you can get while the light holds.

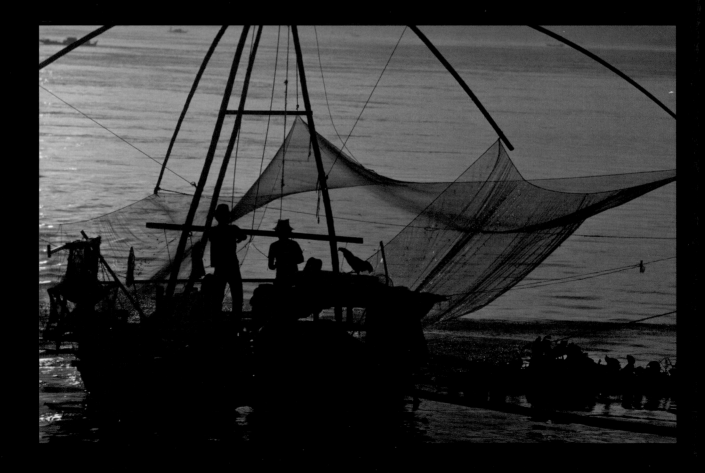

© Frank Gallaugher

→ **Golden shapes**
Reconsider everyday objects
that pique your interests
as they are illuminated by
golden light.

Challenge
Checklist

→ Keep a timepiece of some
 sort with you, in order to
 gauge how long the sun
 will keep its angle and to
 pace yourself as you work.

→ A tripod may also be
 handy, as the light rapidly
 gets lower and lower, and
 longer shutter speeds
 may be required.

→ Consider your angle—you
 can use golden light as
 either a frontal, side, or
 backlight, depending
 on where you position
 yourself in relation to
 your subject.

Review

© Kelly Jo Garner

San Juan del Sur, Nicaragua, is renowned for its golden glow at sunset. I was taken in by the caramel hue of the wood contrasting with the hard shadow, and the soft blue and white of the clouds.
Kelly Jo Garner

A good exposure to capture the richness of color, and a good decision to let the shadow under the eaves go black. The cable at top left, however, distracts my eye. I wonder if stepping to the left and framing lower to take in less of the sky and more of the window frame was a possibility at the time?
Michael Freeman

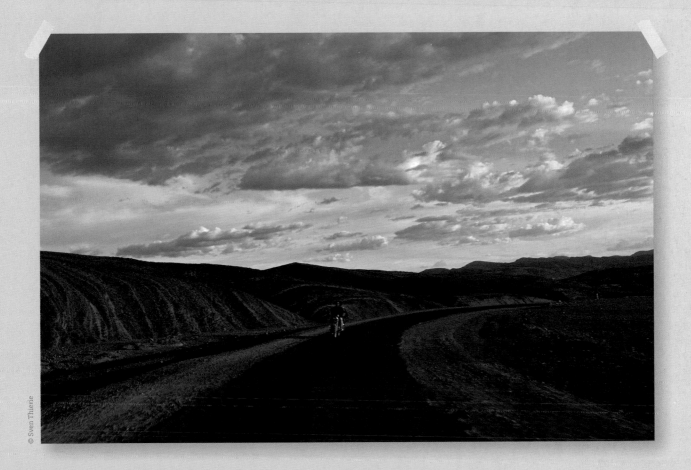

© Sven Thierie

This was taken out the back of a moving vehicle—I realized we weren't going to make it to our destination before sundown, but I wanted to capture the lush gold colors of the countryside while there was still enough light.

Sven Thierie

Quite a nice color contrast between the saturated oranges and the blue sky. The slightly off-kilter horizon doesn't really bother me, as it communicates a certain sense of velocity that is appropriate for an on-the-road shot.

Michael Freeman

Clouds & Light

Almost everything we've discussed so far about the role of daylight in photography has ignored a major factor: clouds. On a perfectly clear day without a cloud in sight, you can use the previously described rules and patterns to predict exactly where and when a certain kind of light will shine with reasonable accuracy. Clouds, however, are giant floating variables that literally change with the wind and will consistently keep you on your toes. Sometimes a blessing, sometimes a curse, clouds interact with light in several key ways, and understanding these interactions is essential. Overcast days with uniform cloud cover are commonly (and unfairly) perceived as dreary and bland. Some of this is simply human perception, which associates bright white light with natural beauty. Beyond that, without any point-source light in the sky, there is nothing to cast distinct shadows, and scenes can easily appear flat with little detail. However, imagine your giant outdoor studio again, and recognize that by spreading and softening the sunlight, the clouds are acting as an immense diffuser in the sky. The resulting soft light means you can take a portrait almost anywhere without worrying about unflattering shadows or high-contrast exposure problems. Indeed, it means you have a lot less to worry about in general, as the entire landscape is evenly lit with a consistent light that won't be dramatically changing from hour to hour. And while colors won't pop with the same intensity that they do under direct sunlight, the soft light does make it much easier for your sensor to capture subtle and nuanced color variations in your subject.

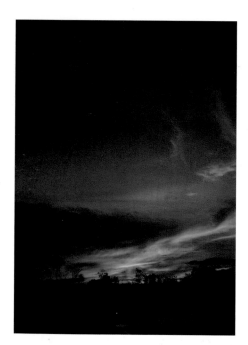

↑ Saturated Skies
The vivid colors of a sunset are best captured by a bit of intentional underexposure, which will in turn render objects on the earth as silhouettes.

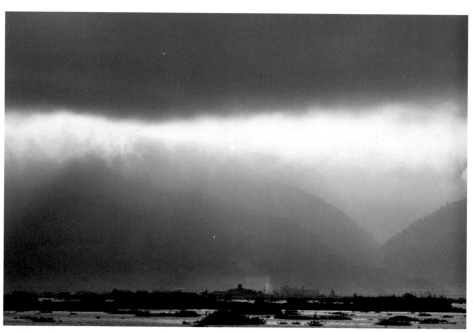

↑ Looming clouds
Besides casting everything below in a diffuse light, heavy clouds like this can also become a major part of the composition itself.

Broken Cloud Cover

In between a perfectly clear day and a heavily overcast one, there are days of mixed daylight, in which a bright blue sky is interspersed with clouds of varying shapes and sizes. Compact and dense clouds (called cumuliform) can dramatically alter a scene for brief periods of time as they pass in front of the sun. In an open scene, the blue sky reflection (10,000K) is usually overwhelmed by the intensity of the sun (5200K); but by blocking and lowering the intensity of the direct sunlight, a cumuliform cloud will momentarily equalize the color temperature to around 6000K, delivering a brilliantly lit foreground that keeps the deep tonality of a blue sky overhead. Of course, these dense clouds also cast quite distinct shadows of their own, particularly if they are low in the sky, which can create high-contrast exposure situations if those shadows are kept in frame.

Clouds as Reflectors

At certain angles, tall cumuliform clouds that extend vertically upward in the sky can even act as light sources themselves, reflecting the light of the sun onto a scene below. Huge banks of such clouds can fill in shadows and help even out the exposure— particularly if the sun is shining upon them from the opposite side of the sky, as in mid-morning or mid-afternoon (earlier or later and the sun is already too low in intensity to have much effect). Even if the light reflecting off these clouds is not enough to completely fill in shadows, it can still lower the color temperature of the shade and bring it closer to the

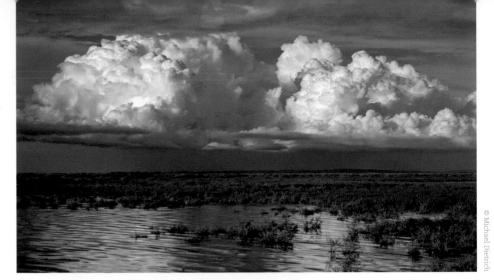

© Michael Dietrich

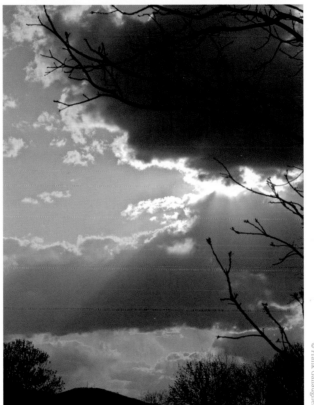

© Frank Gallaugher

↑ Cumuliform composition
These tall cumuliform clouds reflected enough sunlight to evenly illuminate the marshes below, and are also reflected themselves in the water, where they emphasize the textural qualities of the ripples along the surface.

← Breaking through
Clouds can create truly spectacular lighting effects depending on their interaction with the sun. Here, strong edge lighting gives these clouds a radiant outline; and they in turn transform the sunlight into radiating beams of light, which would otherwise be invisible against a clear sky.

temperature of the surrounding daylight, making these shadows appear less blue.

Broken clouds are often unpredictable in the way they scatter light, and this can make them more exciting and also more complex to photograph. This complexity is exacerbated in situations when different layers of broken cloud hang at varying depths throughout the sky. A scene with distant mountains, for example, could have a bank of heavy cloud hanging in the distance, but scattered lighter clouds in the foreground.

Make the Most of a Cloudy Day

↓ Drama from above
As the sun sets, not only does it give the sky take those characteristic warm tones, it also acts as a modeling light on the clouds, giving them greater dimensionality and revealing finer contours and textures within them—which can make an otherwise drab cloud cover come to life.

Next time you see a dreary, cloudy sky out your window, grab your camera and rise to the occasion! You won't need much equipment for this challenge, as you aren't likely to encounter difficult, high-dynamic-range lighting conditions that require filled-in shadows or delicate exposure calculations. Rather, this is all about finding the right subject that benefits from the soft, diffuse light of an overcast sky.

Begin by recognizing that on an overcast day, you are surrounded by the kind of light that professional photographers spend hours trying to mimic in the studio with a plethora of high-tech lighting accessories. Toward that end, look closely at the colors around you, and see how easy it is to capture their full spectrum on an overcast day. You may wish to include the clouds themselves in your shot, or not; that will depend on your composition, and what you wish to express.

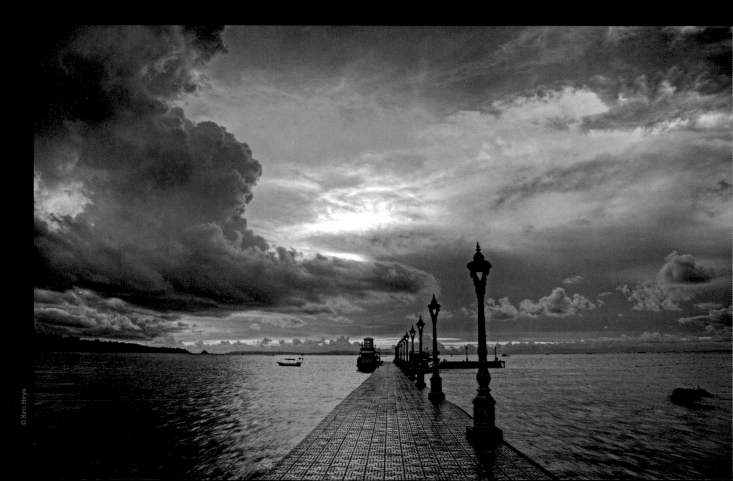

© Ben Heys

→ Catch the light

Subjects with broad, highly reflective surfaces, like these large metallic flood barriers, can add some dynamism to a dreary day by adding catching even weak, diffused sunlight and reflecting it with a brighter sheen.

Challenge Checklist

→ If there's a chance of rain, have something to stow your camera in to prevent it from getting wet.

→ You don't have to avoid the sky altogether, but beware that including large swaths of uniform cloud cover in your frame isn't the most exciting compositional element. Concentrate instead on the colors you see on the ground, and include just enough sky to serve as a counterbalance.

Review

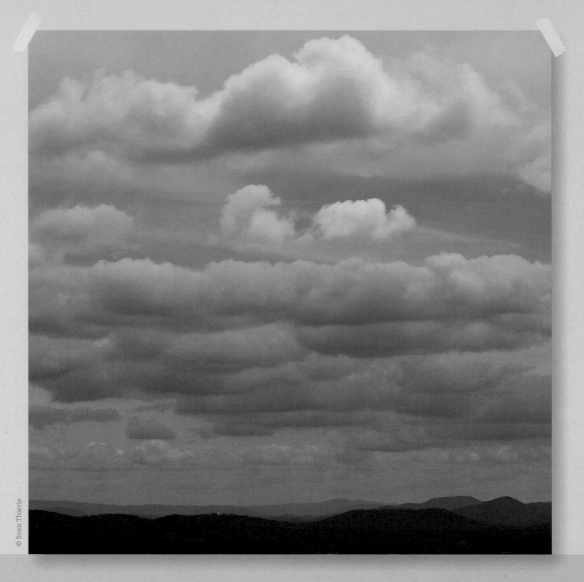

© Sven Thierie

I'd been shooting landscapes from atop a mountain for some time before I realized that the sky itself was more interesting than the views I had of the valleys below.
Sven Thierie

I like the blue color cast here, particularly how the atmospheric haze renders the mountains along the bottom of the frame the same color as the stripe of blue sky shining through the clouds. It's a skyscape with the land just keying the composition.
Michael Freeman

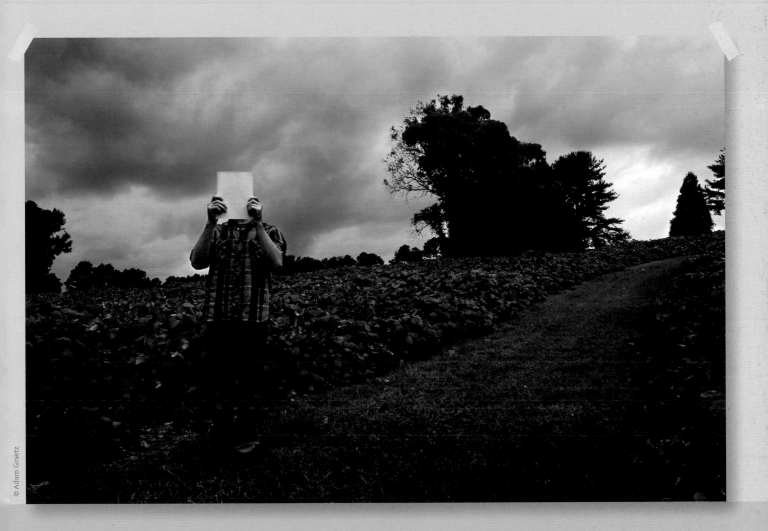

© Adam Graetz

This is an HDR shot—one photo was exposed for the shadows to maintain a greater level of detail in the foreground, and another shot exposed for the clouds in order to retain their ominous, dramatic look. Together, they illustrate the drama of the scene, which would have been impossible with a single shot.

Adam Graetz

Excellent use of HDR—restrained and purposeful, rather than going for that non-photographic, illustrated feel that is so overdone these days. The subject gives it a surrealistic flavor without falling for the temptation of adding to it in the processing! Evocative and moody, the dense clouds complement the strangeness of the human subject.

Michael Freeman

Weather Extremes

Extreme weather can be hard on your camera but simply because it's extreme and less usual, can offer good opportunities for strong imagery. Simply take the necessary precautions against water, sand, condensation or whatever else, and look for one-of-a-kind images.

↓ Foreboding contrast

A momentary break in cloud cover fully illuminated this old Cape Town hotel, contrasting strongly with the heavy, morose storm clouds above. A few seconds earlier or later and the whole scene would have simply looked dull and dreary, with no point of comparison to illustrate the power and magnitude of the weather conditions.

Storms

The default lighting condition of rain or thunderstorms is basically the same as that of an overcast day, only darker. Even though the clouds themselves may look vast and intimidating, they require a contrasting light source to illustrate their contours and bring the scene to life. This happens during momentary breaks in the cloud cover, when the sun cuts through as a strong, directional spotlight that illuminates a single subject amidst a sea of darkness. You must act quickly to seize such opportunities, as the natural windy conditions of the storms mean they will be short-lived.

Approaching storm clouds on the horizon can make for a dramatic landscape, with massive, multilayered cloud formations looming over and contrasting with an otherwise tranquil scene in the foreground. A successfully captured bolt of lightning is also a dynamic element to add to a scene, but unless you get lucky, you will need a long shutter speed to negate the uncertainty of when it strikes. Fortunately, the dark conditions of heavy cloud cover make such long exposure times feasible—provided you use a steady tripod.

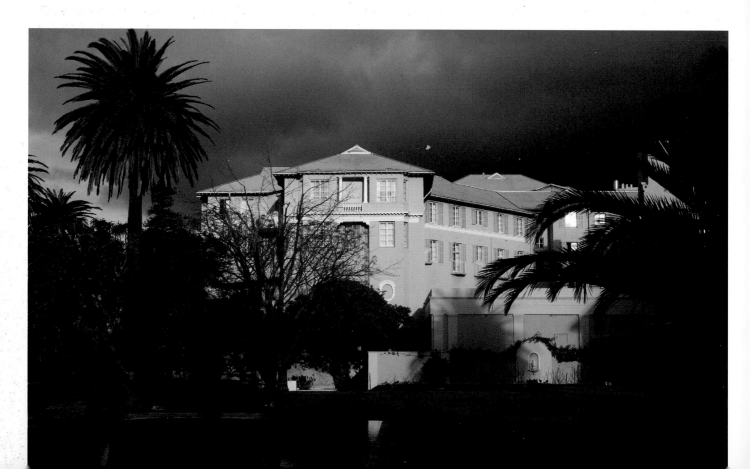

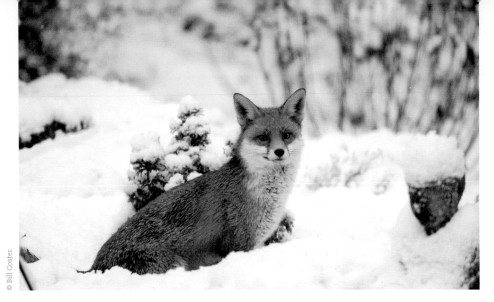

← Nowhere to hide
With properly calibrated white balance, a snow-covered scene serves as an ideal backdrop for showing off vivid colors and textures, such as this European red fox's fur coat. The fox is also evenly lit on all sides by the reflected sunlight.

↓ Ethereal early mornings
Early morning fog, just barely illuminated by the rising sun, creates dreamy, otherworldly environments. To get subjects in sharp focus, you must be physically close to them—shooting across a distance with a telephoto lens introduces too much atmospheric haze for crisp results.

Snowfall

The pristine conditions of a fresh coat of snow make for idyllic imagery, and present a unique lighting condition in which every available surface acts as a reflector. The abundance of white befuddles the camera's metering system, which will interpret the snow to be neutral gray and render the scene accordingly. To prevent this dull underexposure, add one or two f-stops of exposure compensation while keeping an eye on your histogram, until the scene appears correctly on the LCD. On the other hand, you should have little to no problem with unflattering shadows cast on your portrait subjects, and can photograph freely even in direct, midday sunlight.

Cold Batteries

Extreme weather conditions can take their toll on your equipment, and cold temperatures in particular will sap battery strength quickly. Keep a spare battery warm inside your jacket and periodically switch it out with the one in use to extend the life of both batteries.

Mist and Fog

Thick mist or fog swathes a scene in vapor particles that scatter the light and act like a ground-level diffuser cloud. Like most weather extremes, these conditions are usually fleeting—particularly the mist formed overnight by still air cooling over wet ground, which quickly evaporates in the morning sun. Fortunately, you needn't worry too much about exposure, as these scenes are typically low in contrast and easily captured by the sensor. Indeed, you even have some wiggle room—exposing for the whites of the fog will make it glow and appear luminescent, while less exposure will deliver gloomy, eerie results. Shooting through mist introduces a strong element of depth into your image, with objects gradually appearing paler and less detailed the farther they are from the camera.

Challenge

Your Choice of Rain, Fog, or Snow

↓ **Moody backlighting**
Sometimes you just know certain areas will look fantastic in heavy fog. Next time you wake up to a thick early-morning mist covering the ground, grab your camera and head to that spot.

This challenge might entail getting your feet wet—but not your camera! Step one of any inclement-weather shot is properly protecting your gear. If it's just a light drizzle, you might be safe just keeping your camera guarded underneath a raincoat, and taking it out only once you've found a good subject. But don't take any risks. If it looks like it's going to pour, it's worth investing in a good camera cover—which will also be just as handy if you're out trekking in the snow. But the point is to embrace the weather and capture a shot that shows off these less-than-comfortable conditions in all their photographic glory.

© Linda Bucklin

→ Fade into the distance

In heavy fog, look for repeating subjects leading away from the camera, as the fog will gradually obscure them, adding both depth and mystery to the image.

Challenge Checklist

→ In cold weather, bring extra batteries, and keep the extras secure in a warm place.

→ Be alert and ready to grab a shot when it presents itself—fog and rain are particularly ephemeral conditions, and if you wait too long to set up a shot, the light may have changed by the time you fire the shutter.

→ If you can position yourself high up on an overlook or some other vista with a wide view, you'll be able to capture an all-encompassing feel of a weather event—a thundercloud over a valley or a city submerged in fog.

Review

© Sven Thierie

It took a while for the mist to clear enough to see the city in the background, and less than an hour later it was all cleared up and the sun was shining. This was the best time for the shot, with an interesting foreground against a misty, ethereal background.
Sven Thierie

Excellent evocation of mood, and perfect timing for the light. The low camera position places that seagull very well against that light band below the buildings, and the other seagulls help the foreground. It might have been better without the figure at the right bending away—either by a slight re-framing or by cropping.
Michael Freeman

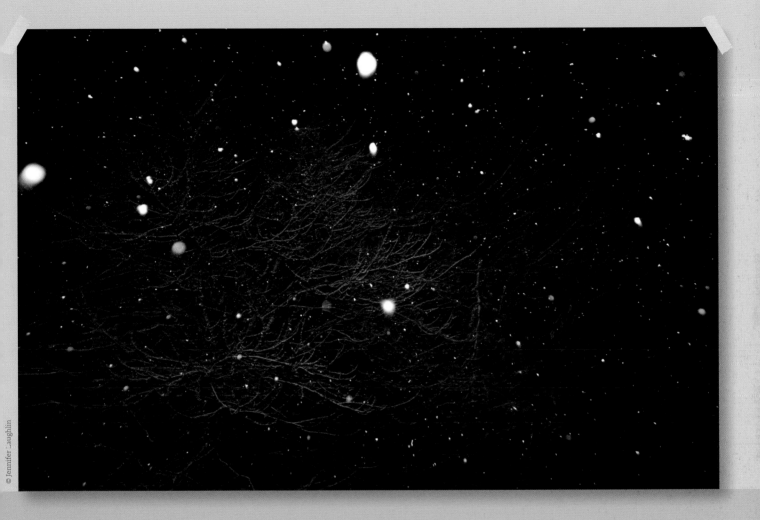

© Jennifer Laughlin

Shot with Nikon D300 and sunpak flash using the tops of the trees as my background. The flash helped me catch the snowflakes even though the snowfall was relatively light.
Jennifer Laughlin

Quite a nice way of turning a problem (flash on foreground elements, in this case snowflakes) into a slightly unusual image—spare and understated. It would be interesting to know how many frames were shot to get this one.
Michael Freeman

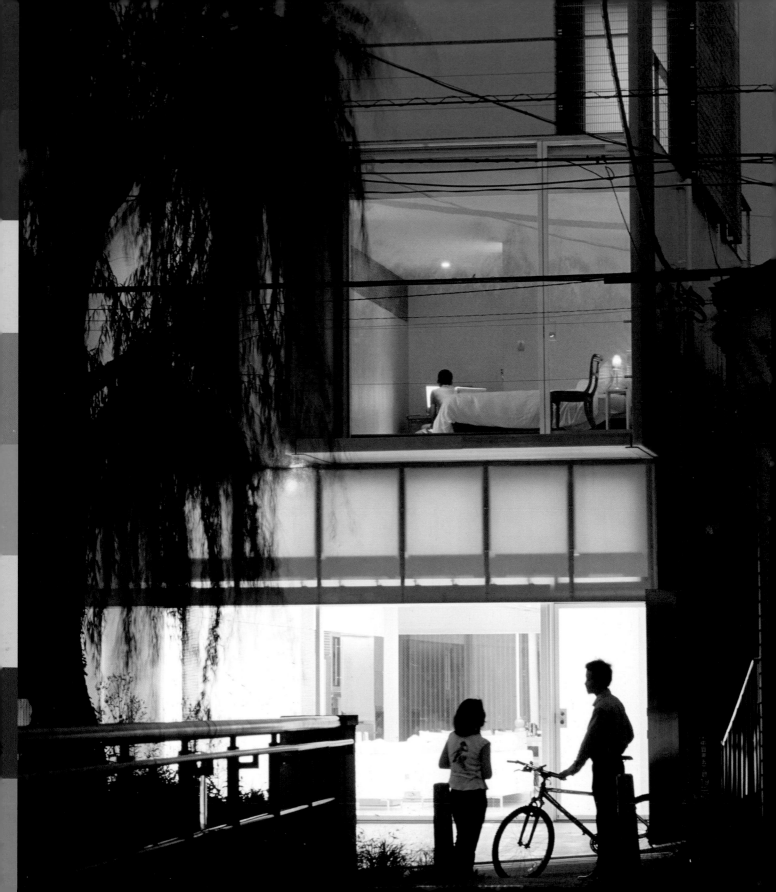

Artificial Light

People long ago stopped relying on the sun as their sole source of light. From meager beginnings of fire and candlelight, our lighting repertoire has evolved to a veritable symphony of artificial light sources, each with its own unique characteristics. Learning to recognize a particular light source and how it interacts with a scene allows you to compose a shot both correctly and creatively.

Decisions regarding artificial light often take place along a spectrum: On one side there is the ideal, scientific representation of light, where white balance is perfectly accurate and all colors are faithfully reproduced; at the other end, there is a highly subjective portrayal of the scene as you experienced it, complete with a sense of mood and connotation. Negotiating this spectrum is what makes photography an art rather than a science; and it is also what makes photography a joy, with plenty of room for expression and creativity.

There is a strong, if often unconscious, association between a type of light and the place in which it is typically found. Hardly anyone illuminates their home with flickering, green fluorescent tube lights; but we expect and accept such light in public spaces and buildings. Likewise, it would be odd to see a large monument at night illuminated by the red glow of tungsten. Each of these types of light carries with it a whole set of associations; and as photographers, we can use these associations to add meaning to our images.

Incandescent Light

Anything that emits light as a result of being heated is said to be incandescent. Fire is the most obvious example of this type of light, and the warm glow of a flame is its signature color. Today, the most common light source used in interior spaces is still traditional incandescent light, but candles and gas lamps have been replaced by tungsten bulbs. These are the classic light bulbs containing a tungsten filament encased in a sealed glass bulb, which is heated by an electric current that warms the wire to a bright glow. The resulting orange/yellow color is (counter-intuitively) relatively cold and falls at the bottom end of the color temperature spectrum.

This method of generating light is exceedingly inefficient, however, as a great deal of energy is wasted in the production of heat rather than light. As a result, numerous sources of incandescent light are required in order to fully illuminate a space, which means a greater likelihood that those light sources will appear within the frame of any given interior shot. The resulting high dynamic range means you will have to approach your exposure with a discriminating eye—either leaving the area nearby the light sources overexposed, or filling in the shadows by adding your own light to the scene.

← Incandescent decorations
This decorative screen in a restaurant was diffusing the light from several tungsten lamps on the other side. Another color would have been far less interesting, but the same warmth that made the restaurant feel comfortable and inviting makes this image evocative and exotic.

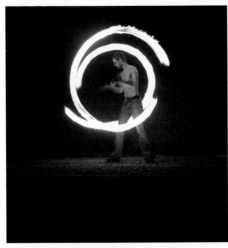

←↓ Three takes on color correction
The flames twirled about by this fire dancer
cast a quintessentially incandescent light. The
picture on the far left shows how strong the
resulting color cast can be if not corrected. Auto
white balance, shown in the middle, gets the
white balance almost perfect, but the result
lacks ambience and feels (ironically) artificial.
The custom white balance set for the image
below strikes a good balance, and appears
very much how the scene felt at the time.

Incandescent
Color Correction

As with any artificially lit scene, it
is imperative to keep a close eye on
your white balance settings to avoid
unwanted color casts. Your digital
camera's incandescent/tungsten WB
preset is usually around 3200K, but this
is calibrated for studio lamps. Domestic
light bulbs have no such standard color
temperature—a 40-watt tungsten bulb
is cooler than a 100-watt one, and
candlelight glows at an even lower
temperature than either. To completely
eliminate the orange-yellow color cast,
you will need to manually dial in a
lower white balance setting, or set
a custom white balance.

However, you may find such precise
adjustments unnecessary and even
undesirable, as a perfectly balanced
incandescent scene can often appear
sterile and artificial. Our eyes are long
accustomed to incandescent light, and
associate its orange color cast with
warmth, familiarity, and comfort. It can
lend a sense of intimacy to a group
shot, and make an interior feel inviting.
A delicate touch is still essential.

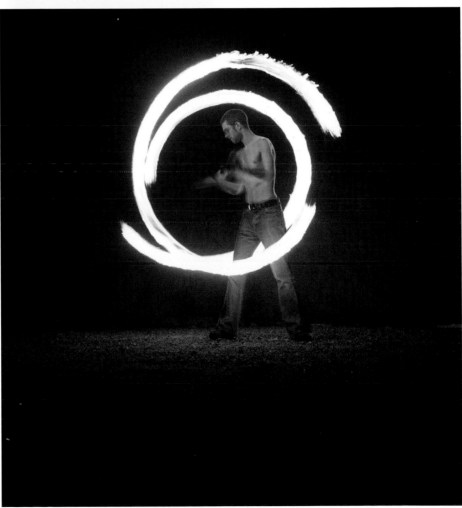

Fluorescent Light

More common by the day, fluorescent light is far more efficient than tungsten bulbs, using less energy to create brighter light. They work by passing an electric charge through a gas encased in a tube, the interior of which is coated with phosphors that excite in reaction to that charge and emit light. Due to their efficiency, fluorescent lights have been popular in industrial and commercial spaces for decades, and are now making their way into energy-conscious domestic homes as well.

This is all well and good for the environment, but rather unfortunate for photographers, as fluorescent light has never been considered particularly flattering. Besides the fact that we've come to associate it with sterile, commercial spaces, this type of light is also completely unnatural—in fact, it had to be shoehorned into the color temperature spectrum between early morning/evening and afternoon sunlight. This was done for the sake of convenience, but in reality fluorescent light is not continuous the way incandescent or sunlight is. Rather, it is comprised of distinct spikes in blue and green channels, with gaps in the reds. Your mind does a good job of filling in these gaps such that a fluorescent-lit scene is perceived normally, but imaging sensors have a harder time of it.

That said, the fluorescent bulbs used in modern domestic residences have come a long way from the long tubes used in schools, offices, and other dreary public spaces. Special care has been taken to make their phosphors

↑ Tokyo underground
Public spaces like this underground station are often lit with inexpensive fluorescent lamps. In such locales, getting the white balance absolutely perfect isn't always necessary, as long as the color cast isn't overly distracting.

emit a hotter light that closer approximates natural white daylight, and their power-up mechanism is smoother, preventing the headache-inducing flicker so loathed in traditional fluorescents. These compact fluorescent lights (CFLs) are so-called because their tube is wrapped up in a spiral or loop, making them much smaller and able to fit in traditional tungsten lamps.

Tungsten vs Fluorescent

The graph below illustrates the continuous spectrum of tungsten light, and the fact that it is comprised of all the different colors of light means it can accurately illuminate each of those colors in an image. Fluorescent light's spectrum, on the other hand, is broken and discontinuous, with sharp spikes in cool colors and hardly present at all in the warmer ones. Among other things, this is why fluorescent lights are so unflattering for showing off skin tones (which are themselves mostly comprised of reds and yellows).

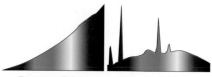

Tungsten light Flourescent light

Fluorescent Color Correction

As usual, your first tool in compensating for the green hues of regular fluorescent lights is your camera's corresponding WB preset (usually around 4000K). But even if you set a custom white balance specifically for a given fluorescent lighting condition, the gaps in that light may nevertheless result in a scene with slight deficiencies in color accuracy that remain perceptible to the viewer. Fortunately, the spaces in which you typically encounter such light are often expected to be rendered with those characteristic green hues—the viewing public has simply grown accustomed to perceiving light in these spaces this way.

Domestic residences in which you typically find daylight-balanced CFLs, on the other hand, need special care to avoid casting an otherwise inviting home in a lifeless, impersonal light. Newer digital cameras often have a separate WB preset specifically for these lamps called Fluorescent H, which is slightly warmer at around 4500K. But given the unpredictable and inconsistent quality of these lights (the color of which can even change based on the currency of the mains outlet into which it is plugged), your safest bet will still be to set a custom white balance with a gray card and shoot Raw, enabling the most leeway for fine-tuning adjustments in post-production.

↓ **A happy medium**
The camera initially rendered this warehouse interior with an unappealing green color cast due to the fluorescent lights above. Auto white balance, applied in post-production, went too far in the other direction, with too much magenta. In the end, a custom white balance set for a cool blue cast was preferable, as it speaks to the industrial feel of the scene.

Color Balancing Interior Spaces

↓ Behind the bar
If you're feeling up to it, you can try photographing commercial spaces, which are typically lit by a variety of light sources and designed to be dynamic and interesting. In some cases, you can leave obvious color casts—such as the strong blue lights behind the bar in this shot—as they lend a graphic atmosphere to the shot.

Taking what you know so far about artificial light sources, you should now challenge yourself to photograph an artificially lit indoor area. You'll most likely be shooting under either fluorescents or tungsten lights, and while you search for your shots, look closely and see if you can pick up on the normally imperceptible color casts that surround you every day.

Pick an interior space where you'll have time to move about and set up your shot. Keep an eye out for mixed light sources and try to avoid them, as this will complicate finding the right color temperature and often requires post-production work to get it right. However, the point of this challenge is then to render the scene as you see it—which may not be a perfectly balanced white.

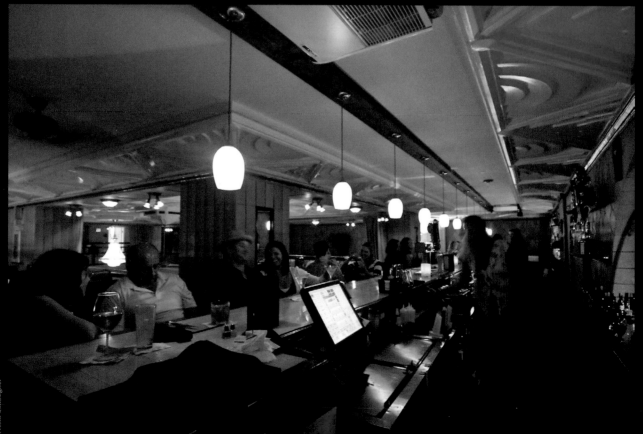

© Frank Gallaugher

→ Cathedral of Cordoba

There is daylight coming in at the far end of this enormous prayer hall, but going with a much warmer, tungsten color cast does a much better job of communicating the somber antiquity of the structure.

Challenge Checklist

→ Shoot Raw, so that you have total control over white balance settings in post-production.

→ You should still, however, experiment with your WB presets, and try at least to get the color temperature in the right ballpark. Reviewing shots on the LCD is key.

→ Avoid windows that may be contributing strong, blue-tinted daylight. Either keep them out of frame, or cover them up with a shade.

Review

© Adam Graetz

This was a purely coincidental shot that I took at a moment's notice. I chose to keep the yellow/green cast to preserve the urban mood of the lights in the subway station late at night.
Adam Graetz

Going overboard on the yellows and greens feels right at home in an underground tube station. The image feels appropriately industrial and urban as a result.
Michael Freeman

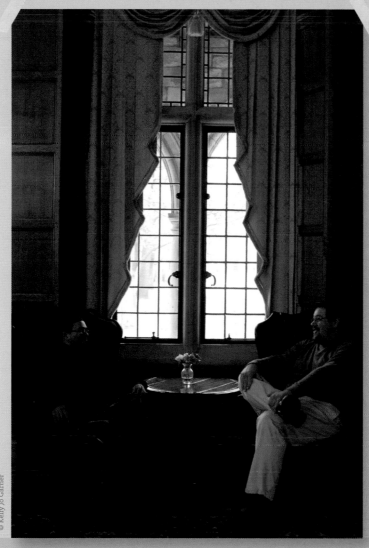

© Kelly Jo Garner

These are two of my best friends in the universe, and we spent a happy day gamboling around the campus of the University of Michigan. Andy, on the left, showed Jason and I his old dormitory quarters, and I jokingly took a shot that I said would be submitted for the campus catalog.
Kelly Jo Garner

Quite right to choose a white balance that renders the window light neutral (blue would have been a distraction). Technically, though, the interior light is not quite strong enough, and I feel the figure at left is lost in darkness.
Michael Freeman

Vapor Discharge Light

Illuminating large, outdoor spaces like city streets, parking lots, and football fields requires a high-intensity light source beyond the capabilities of tungsten or fluorescent lamps. Vapor discharge lamps meet this challenge by creating a powerful arc of electricity between two electrodes housed inside a sealed tube. Once the arc is formed, it evaporates metal salts that are contained in the tube, creating a luminescent plasma. The color of the resulting light is dependent on the metal salts used. Because it takes time for the metal to evaporate, these lights initially cast one color when they are first turned on, gradually shifting to another as more metal is evaporated.

↙ Color science fiction
This technological display was illuminated by mercury vapor lamps, and the uncorrected blue color cast suits the subject well, communicating a futuristic and alien atmosphere.

↑ A scene on the Seine
In the streets and sidewalks where sodium vapor lamps are most common, the light is often quite localized, with discrete patches of illumination that can serve as excellent compositional elements.

Mercury Vapor Lamps

These are the most common vapor discharge lamps, and their glowing mercury emits a broken spectrum of light much like fluorescents. Though perceived as a cool white by the human eye, their color starts off as a strong green before shifting to a bluer hue. The intensity of these blue-green spikes is even greater than that of fluorescents, and is more difficult to correct.

Sodium Vapor Lamps

The light emitted by plasma-state sodium starts as a strong orange before shifting to yellow, with severe deficiencies in all other color channels. As a result, they cannot be color-corrected to perfectly balanced white, because there is no other color to recover. These are the most common light sources in urban areas like city streets—so common, in fact, that their cumulative effect is what makes cities shine yellow at night when seen from far above, in an airplane or from space.

Multi-Vapor Lamps

By combining several different metals, these lamps can emit a cold white light that, in certain contexts, appears quite natural—even to an imaging sensor. For this reason, multi-vapor lamps are also used as studio photographic lights when high-intensity light is needed. They are also used on football fields and sports stadia, where sports photographers need them to capture accurate white balances.

Vapor Discharge Color Correction

With the exception of multi-vapor lamps, getting accurate color from vapor discharge light is usually a photographic nightmare. Your camera probably lacks a WB preset for these types of light, so setting a custom white balance and shooting Raw is your best bet for color correction. However, in the conditions in which you typically encounter vapor discharge light, perfect rendition of color isn't always necessary. We've grown accustomed to viewing street subjects in the strong yellow hues of sodium vapor; and industrial settings often benefit from the greens and blues of plasma-state mercury. So consider what is appropriate for your given subject.

↑↑ **La Grande-Place**
The intricate architecture of Brussels' Grand Place deserved better treatment than the limited spectrum of yellow sodium vapor lamps could afford. Of course, nothing could be done about it at the time this was shot, but in post-production, the yellows were isolated and shifted to a warmer, more grandiose hue.

Mixed Light

Now that you have an understanding of how the particular types of light interact with a scene, you must combine that knowledge and tackle the real world—which is rarely lit by a single, uniform light source (day-lit landscapes notwithstanding). Rather, many spaces reflect light from multiple different sources, each with its own color temperature and characteristics.

Generally, there are three approaches to dealing with mixed lighting, the easiest being to simply set your camera to Auto white balance and let it determine an average color temperature for the scene. Depending on how diverse the various light sources are, this can work quite well—grays and whites may be skewed a bit, but no single color will be completely off-target. Or you can go the opposite route and set your white balance for only one particular light source, leaving all other colors to shift accordingly. This can be a good approach if one light source is dominant, and the inaccurate colors aren't too distracting.

The final and best option for color correcting mixed lighting involves adjusting each light source separately, and can be done only in post-production. There are a few different approaches here, but the most effective is to use the Replace Color tool (in Photoshop: Image > Adjustment > Replace Color...). This allows you to isolate one particular color and shift its hue, saturation, and lightness independent of all other colors, bringing it into harmony with the rest of the scene.

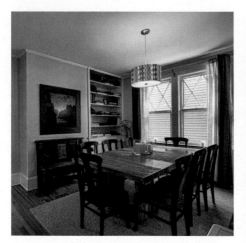

↑→ Balancing window light
The important element of this scene was the interior space, which needed to feel warm and inviting. Therefore, the original white balance was set for tungsten, disregarding the daylight shining through the windows (above). However, the resulting blue color cast on the right side of the frame was too distracting; so in post-production, that particular blue light was isolated and then desaturated to a neutral white (right).

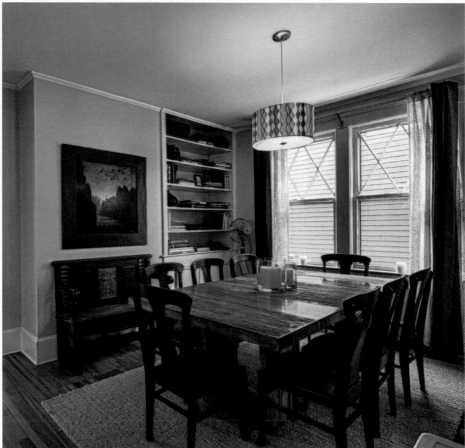

© Frank Gallaugher

City Lights

City lights can be considered the ultimate style of mixed lighting. Vapor lamps are now a common choice to light municipal areas, and require a deft diagnosis of which variety is being used. In combination with this, a shop-lined street will often shine forth a row of tungsten-lit frontages, while neon is used overwhelmingly in certain other districts.

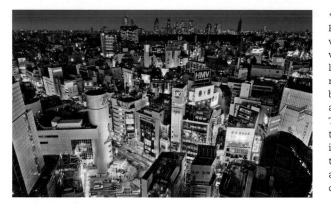

← Diverse cityscapes
Fluorescent in the office windows, tungsten and vapor discharge at street level, all interspersed with radiant neon signs—the bombardment of light within a city is all part of the appeal. This diversity is what makes them so photogenic, and the innumerable color casts are testament to the excitement and randomness that characterize a metropolis.

Commercial Spaces

The light within shops, malls, and other commercial buildings is meticulously designed to encourage consumers to linger, persuade them to move on more quickly, or plot a particular course through a retail space. For this reason, the current trend is to use a mixture of incandescent, vapor discharge, and fluorescent lighting to achieve the desired effects, and this must be accounted for by the photographer. Fortunately, the effort put into the lighting design pays off with a well composed and delicately balanced scene, which is often simple to photograph. Indeed, high-end shops and galleries go to great lengths to ensure their ambience is worthy of their expensive goods and services, offering up lush photographic subjects.

© Frank Gallaugher

→ Arcades interiors
One of the world's first shopping arcades (and the precursor to the modern indoor mall), the Galeries Royales Saint-Hubert in Brussels is illuminated by daylight through its gigantic glass roof. The mix of warm sunlight from above and artificial lights in the shop windows makes for a dynamic and grandiose subject.

Nighttime Cityscapes

↓ Cutting through

Although you don't normally think of a moonless night sky having much color in itself, a long exposure often records the sky in beautiful blue tones that can match brilliantly with the orange hues of street lights.

Night photography often pushes the extremes of your camera's limits in terms of its light-gathering ability (ISO), aperture, and shutter speed. If you've got the time, however, it's best to use your lowest ISO and a medium aperture to ensure maximum image quality. With such low shutter speeds you'll need a tripod to hold your camera completely still as you work to prevent blurring—unless you have decided to use blur as a creative technique. Besides, this challenge embraces the slow-and-steady, methodical approach of a landscape photographer, and it's likely that by the time you find the right position to take your cityscape, you'll want to spend plenty of time trying out various exposure settings.

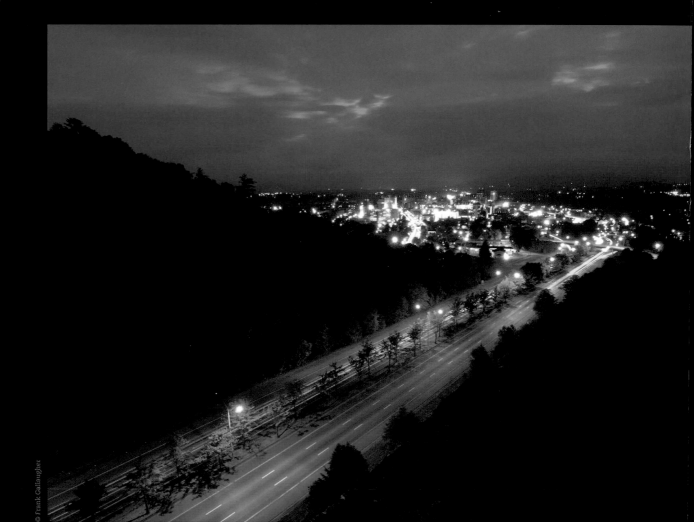

© Frank Gallaugher

→ **Telephoto city views**
If you can't get far enough away for an all-encompassing view of your city, try picking out a landmark, monument, or some other interesting and characteristic building.

Challenge Checklist

→ Like most nighttime shots, the moon can be a strong compositional element if you want to keep it in frame.

→ Don't worry too much if you set up in front of a busy street—if the shutter speed is long enough, the traffic should end up as transparent streaks (if it shows up at all).

→ Even if you're using a narrow aperture for plenty of depth of field, focus is always a challenge at night. Zoom into the LCD screen to evaluate fine focus after each shot and make sure all the key elements are sharp. (This will also let you know if there's any camera-induced motion blur in the shot, possibly requiring a more delicate release of the shutter next time.)

Review

© Adam Graetz

The Chicago skyline is absolutely stunning, and I liked this particular angle for its tighter, more compressed telephoto view and the darker buildings constituting the foreground.
Adam Graetz

The mix of yellow sodium vapor lights, white spotlights, purple on the tallest tower, and green and blue fluorescents works well, though the lower-left third of the image looks a little dead by comparison. I'd suggest a different framing, perhaps a tighter crop on the upper right.
Michael Freeman

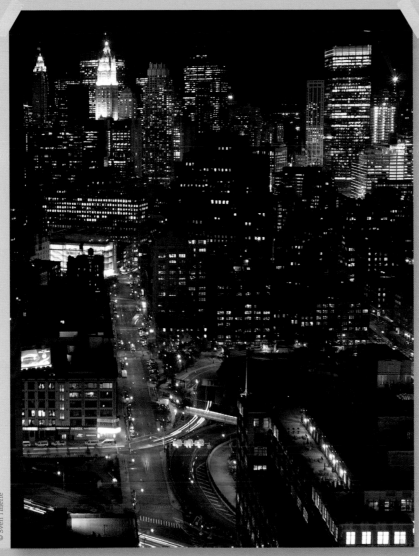

© Sven Thierie

I was very fortunate to be invited up to the top floor of a Manhattan skyscraper, and spent my whole time glued to the windows, shooting down from every angle. I braced by camera directly against the glass to facilitate the long shutter speeds.
Sven Thierie

I like how, from this angle looking down, the sodium vapor lights clearly distinguish the streets below. Even the street you can't directly see on the far right is indicated by that trademark yellow glow. It's also a well-organized composition using verticals and horizontals.
Michael Freeman

Photographic Lighting

Embracing photographic lighting is a challenge, as it opens a completely new dimension in your photography. No longer is it enough to simply observe a subject, evaluate its lighting conditions, and shoot accordingly (which is a complicated enough process in itself). You must now ask yourself how you could augment, modify, or negate that light toward your own end. Is it a fleeting moment in which you must quickly set an external flash unit to the proper output level and fire away? Or do you have time to set up a backdrop, diffuse the ambient light, and brighten up shadows with a reflector? Perhaps this isn't even the right location for this subject, and you should move it into your studio and have total control over the lighting conditions. Of course, introducing a studio initiates another cascade of questions that must be answered, regarding the appropriate type of light sources, what kind of setup to assemble, and so on.

Rather than attempt to be a jack of all trades, many photographers choose to specialize and develop their skill in one particular kind of lighting, adapting it to each subject on a case-by-case basis. And rather than being a restriction, this is often an advantage. Not only does it motivate the photographer to become an expert in their field of choice, it also forces a degree of creativity and flexibility which would not develop were every kind of professional lighting device available.

Toward that end, it is important to understand your options, and learn the inner workings of each type of photographic light source and all their associated accessories. Along the way you will develop your own personal style, and be able to make lighting decisions intuitively, creatively, and quickly.

Camera-Mounted Flash

This type of flash can refer to two things: either the built-in flash that is a part of your camera, or an external flash unit mounted in the camera's hot shoe. Built-in flashes are by their nature extremely limited, and are designed almost exclusively for portability and convenience. They can illuminate only a relatively short distance in front of the camera, and their close proximity to the lens axis means a strong, frontal light that is unflattering for many subjects—particularly portraits. External flash units, on the other hand, overcome many of these limitations and add a number of features as well—though these depend on the particular model used. Professional external flash units are considerably more powerful, able to illuminate wider angles and reach farther distances. They are also positioned much higher above the lens axis, and can be rotated up or down and side to side in order to facilitate bounce flash.

How Flash Works

Flash units consist of a power source (batteries, usually), a capacitor, and a gas-filled tube. When the flash is activated, the capacitor builds up a rapid charge from the battery; and when the flash is fired, the charge is released into the tube, where it creates a brief arc of electricity that emits a "flash" of light. The duration of the flash is extremely short, which becomes a problem when using fast shutter speeds with a camera that has a focal plane shutter, like a DSLR. Such shutters are composed of two curtains that travel across the sensor in sequence—the first curtain exposes the sensor, and the second (or "rear") curtain covers it back up. The time it takes for the curtains to cross the sensor falls well below the full range of shutter speeds necessary for most images; so for faster speeds, the rear curtain will start covering up the sensor before the first curtain has finished its crossing. This means that only a sliver of the sensor is exposed at a time. If a flash were to fire at such high shutter speeds, only that sliver between the two curtains would capture its light. For that reason, the fastest shutter speed at which the sensor can be fully exposed is called the camera's Flash Sync Speed, and is the upper limit at which you can fire a flash at full power (often between 1/180 and 1/300 second).

To get around this limitation, external flash units often have a feature called High Speed Sync, which fires several bursts of flash during the course of an exposure—the idea being that the sensor can be fully illuminated by the flash in increments, with one flash per sliver of exposed sensor area. This works well, and allows the use of high shutter speeds with flash; but there's a trade-off: In order to fire such a rapid succession of flash bursts, the intensity of each burst is decreased, so the overall power of the flash is diminished. Fortunately, this is usually an acceptable compromise, as the use of fast shutter speeds typically indicates an abundance of light anyway.

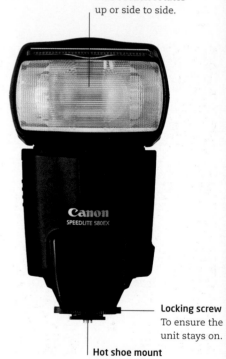

Strobe head
This section rotates up or side to side.

Locking screw
To ensure the unit stays on.

Hot shoe mount
Whereby the flash communicates with the camera.

↑ **Speedlite**
This professional flash unit has a positional head that can be rotated up or side to side, greatly increasing its usefulness. It is also powerful enough to reach far distances.

Inverse Square Law

It is common sense that light gradually decreases in intensity (or "falls off") as it travels greater distances. If you're going to be adding your own light to a scene, it is essential that you be able to precisely predict that degree of fall-off to make sure your subjects are adequately lit. Toward that end, flash photographers work according to the inverse square law, which states that the intensity of light falling on a subject is inversely proportional to the square of the distance from that source. While that may sound like a mouthful, in reality it's quite straightforward. For example, if you have two subjects of equal size, one of which is twice as far from a light source as the other, the more distant subject will receive only 1/4th as much light as the closer subject. In lighting terms: Doubling the distance cuts the light down by two f-stops.

$$\text{brightness} = \frac{\text{intensity of light at source}}{\text{distance}^2}$$

Red Eye

This well known effect occurs when the flash bounces off the retina of a human subject, and increases in likelihood as the angle of flash approaches the axis of the lens. An automated solution is to fire a series pre-flashes in advance of the main flash in order to make the subject's pupils contract. This Red-Eye Reduction feature is generally both annoying and disruptive, causing your subject to squint and announcing to everyone nearby that you are taking a picture. It is further negated by the ease with which red eye can be fixed in post.

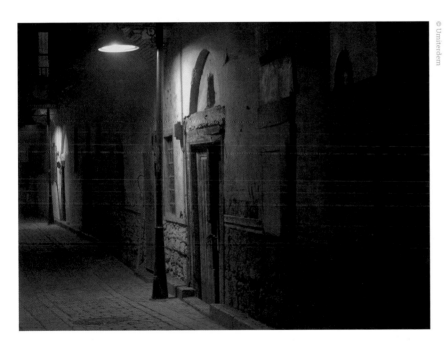

↑ Streetlight falloff
While the inverse square law may seem mathematically complex, its principle is quite familiar. You're aware how quickly light falls off around a lone street lamp like this one; it's just a matter of measuring that falloff to accurately predict how your flash will function in a given scene.

↑ Smaller equipment
Built-in flashes are undeniably handy, and can be made even more useful with simple accessories like this miniature diffusion screen. This will prevent both the red-eye effect, and soften the light output, avoiding the deer-in-headlights look so characteristic of these flashes.

Balancing Flash to Ambient Light

Camera-mounted flash really comes into its own when used as a supplement to ambient light, rather than having to be the primary light source itself. We covered this to some degree in our discussion of decreasing the dynamic range of certain high-contrast scenes so that all the light can fit onto your sensor. Backlit subjects, for example, can have the strong shadows cast toward the camera brightened up to give a well rounded, balanced light. This is called fill flash, because you are "filling in" the shadows by introducing another light source to the scene. You will need to set your flash to a Forced Flash or Manual mode in such conditions, as any of the auto modes will read an abundance of light and disregard flash as a necessity. A light touch usually goes a long way—you want to delicately balance your flash to the existing light conditions without overpowering them. An appropriate ratio of flash to daylight, for instance, is around 1:3 or 1:4.

← **Interior festivities**
Restaurants, reception halls, and other indoor event spaces are frequently quite dim, and rarely conducive to setting up a tripod. Fortunately, they do offer a giant reflector card in the form of a ceiling, off of which you can bounce your flash to cast a diffuse, flattering light on your subjects below.

Bounce Light

In dimly lit interior spaces, your flash is a handy way to augment the ambient light; and by their nature, interiors give you an abundance of reflective surfaces with which to work. By angling your flash up toward the ceiling or to the side at a nearby wall, you can bounce your flash off of those surfaces and back toward your subject. The results are far more flattering than normal frontal light, both because of their angle and the fact that they are diffused into a softer light along the way. Of course, the light now has to travel a farther distance before it reaches your subject, particularly in a large room or reception hall. Therefore, high-powered, professional flashes are preferred, and typically used at full output. Another issue is that the angle of the light may now cast shadows on your subject, and you can't fill them in with your flash because it's already being used for bounce. A quick fix is a bounce card—a reflective surface that need be no bigger than a playing card. This attaches to the back of the flash head and reflects some of the light forward, while still allowing most of the output to radiate up for bounce.

Rear-Curtain Sync

From our discussion on page 92, you know that the two-stage nature of focal plane shutters affects the role of flash at high shutter speeds. You also have option for slower shutter speeds: You can "sync" the flash to either the first or second curtain, so that the flash fires at either the very beginning or very end of the exposure. First- or front-curtain sync is fine for stationary subjects, but if there is any movement in the frame, it means a sharp subject, captured crisply at the start of the exposure, will be obscured by motion blur that overlaps the initial capture. The solution is to sync the flash to the rear curtain (rear- or second-curtain sync)—the very end of the exposure. With motion subjects this is ideal, as the flash will capture a sharp moment that overlaps any blur. The resulting trails of motion blur are quite dramatic and effective.

Rear-curtain sync isn't only about communicating motion though; it is also a method of including distant backgrounds in a dark scene with a nearby main subject. Capturing a sense of place and environment is often essential, and helps avoid the isolating, black backgrounds so typical in poor flash shots. It takes some practice to perfect this rear-sync technique, but the results are often stunning.

© Adastra

↑ **Street sync**
There's a lot of both camera movement (from left to right) and subject movement (in the street background) in this shot, but the woman crossing the frame stands out sharp amid it all—the trademark look of rear-curtain sync.

← **Motion trails**
The blur of motion on the left of this photo was captured without flash, while the ballerina was moving from left to right. When the flash fired at the end of the exposure, she was momentarily fully illuminated, and the resulting sharp image was the last bit of light captured by the sensor. The result clearly indicates horizontal motion, and was particularly appropriate for the subject.

Bounce, Diffuse, or Sync your Flash

Challenge

↓ A flurry of action
Don't look for too much exact precision when using rear-sync flash—the motion blur is all part of the spirit of the shot. There's nothing particularly sharp in this photo, but the subjects are identifiable and the motion trails following behind the runners' legs communicates motion nonetheless.

Now it's time to show off your technical mastery of basic flash techniques. The point is to avoid the dreaded strong frontal light of uncreative, automatic built-in flash and show the range of applications a camera-mounted flash has for your photos. Indoor events will be an excellent place to employ these techniques, as the light is dim and you are surrounded by reflective surfaces

that can serve to bounce and diffuse your flash beam. Additionally, you may want to try out a flash accessory, like a diffuser, to soften the direct light and avoid harsh shadows behind your subjects. Finally, if your subjects are in motion, try using your camera's rear-sync feature to communicate that sense of movement while still preserving the ambient lighting.

© Dusan Zidar

© Frank Gallaugher

→ **Flash for fashion**

If you know you'll be needing flash as a primary light source, be sure to bring along a diffuser to prevent every shot from being flat with obvious shadows.

Challenge Checklist

→ You'll likely be in dim lighting conditions where focus is always a challenge. If you can predict where the action will occur, try manually focusing in advance— checking that you got it right on the LCD—and then waiting for the action to come to you. Then, when you fire the shutter, there won't be any delay.

→ An external flash unit will always be more useful, but don't shy away from using your built-in flash if it's all you have available—and you can still use diffusers to soften its light.

→ Even if you plan on using rear-curtain sync, a steady hand is important, as it will ensure that the part of the scene exposed by the ambient light still stands a chance of being rendered sharply.

Review

© Kelly Jo Garner

Popping an external strobe helps me capture the action in roller derby, a sport often played under difficult lighting conditions. Tracking the skater first and locking focus helps keep the subject clear and up front. Strobe is directly behind me; the skater is right in front.

Kelly Jo Garner

While the use of flash was necessary for exposure, as indoor sporting events are often low-light affairs, the creative choice to use rear sync was excellent: A regular flash wouldn't have captured the blurred background, but this image benefits from those motion streaks to add a sense of dynamism and movement.

Michael Freeman

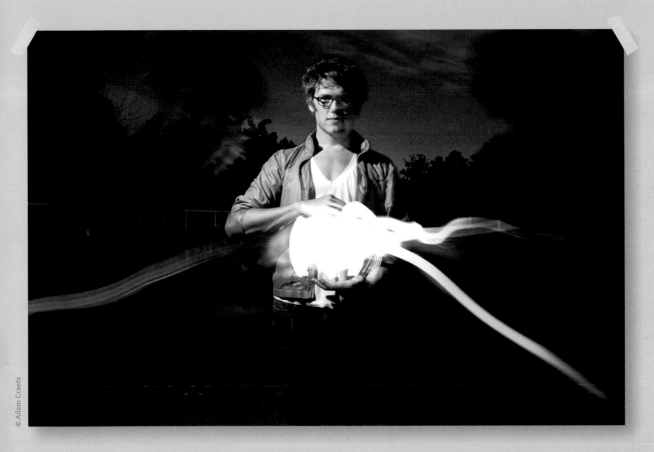

This shot required the coordinated cooperation of several friends. The one in the center remained (mostly) still while the others painted in the glowing orb with LED lights. I particularly like the residual ghost images they left on either side of the center figure.

Adam Graetz

Quite a creative use of rear sync. Light painting alone is a fun technique to explore, but by freezing the center subject sharply at the end of the exposure with a flash burst, the image becomes even more striking.

Michael Freeman

Studio Flash

Whereas on-camera flash is used to make the most out of a difficult lighting situation, studio flash gives you total control over how your subject is illuminated. The trade-offs are obvious: You will need space to set up your flash equipment, and time to test and balance its effect. But for optimal lighting, there is no substitute.

Studio flash can begin by taking your camera-mountable flash unit, attaching it to a tripod or some other light stand, and controlling it from the camera. High-end digital cameras can, in fact, control several external units at a distance, letting you adjust the intensity of each from the camera's LCD screen. But that is, of course, just the beginning. Dedicated studio flash equipment comes in every shape and size, and gives you the ability to choose exactly the right kind of lighting appropriate for the shot.

↑ Extra reach
Superbooms like these can extend high above a subject, facilitating top lighting without the need for climbing up a ladder.

→ Winch mechanism
The wheels on the bottom of this stand make large adjustments in position easy—they can be clamped down once placed to prevent them from drifting around.

↑ Tools of the trade
Professional studio lighting is versatile, powerful, and reliable. It is also invariably expensive.

↓ Support mechanisms
Elaborate setups can be built by assembling these arms, brackets, and bars into whatever configuration is required. Lights can then be clamped on wherever they are needed.

Try Before You Buy

While the cost of professional studio equipment may seem prohibitive, there are alternatives for photographers on a budget. Some studios will rent lighting setups by the day (or even hour) so you can try out equipment for a fraction of the purchase price. If you're just starting out, this lets you get a feel for which equipment you'd find most useful, without committing to buy.

Lighting Supports

As with all photographic lighting, studio flash units must be precisely positioned according to the needs of each shot. Beyond that, because there is a definite trial-and-error component to working with flash, the units need to be easily adjustable as well. Toward that end, proper and sturdy supports are just as important as any other piece of studio equipment.

Modeling Light

Calculating and visualizing the effects of studio flash can be difficult, particularly as you add multiple units, because their light can't be seen until the shot itself is taken. Obviously, the instant review option of digital cameras mitigates this hassle to some degree, but professional studio flashes also include a feature to help you see their effects in advance. A small incandescent lamp, called a modeling lamp, is often imbedded in the unit, right next to the flash tube, and it can shine continuously while you set up your shot. They don't always shine at the exact intensity of the flash itself, but they are a huge help in deciding the angle and distance each flash unit should be from the subject.

Typical Studio Flash Equipment

→ Ringlights

Though technically still on-camera flash, the light from a ringlight is completely shadowless, as it is evenly emitted from all angles around the lens. These are excellent for macro photography, and also portraiture.

↑ Striplights

Ideal for illuminating large backdrops, striplights produce a very even light along their entire length—usually around a metre (3 ft).

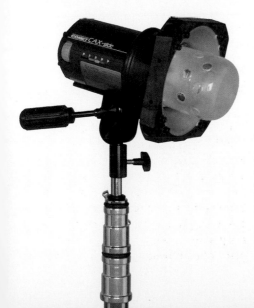

← High-power heads

So powerful that they often have their own cooling fans built in, high-power flash heads can shine across great distances, or diffuse across a wide open space. They can even compete against sunlight in outdoor setups, and are purpose-built for large shots. In smaller setups like macro, they are usually overkill.

↗ Small heads

These discreet flash units can be hidden behind objects within the frame, allowing you to shine light in places where a larger piece of equipment would intrude into the shot.

Continuous Light

These light sources work according to the WYSIWYG principle (that is, What You See Is What You Get). You can observe their effects in real time as you move and adjust them into a proper configuration. This eliminates the guesswork and inverse square law calculations that are necessary in flash photography, and can allow for much more precise and nuanced setups. A lot of this technology was developed in Hollywood, for the obvious reason that a continuous, multiple-frames-per-second movie can't be lit using flash.

Working with continuous lights can be a much more satisfying experience than flash. Because it is a constant presence in the studio, the light tends to take on a more tangible and palpable quality. It starts feeling like a set piece. Additionally, you can walk throughout your setup and observe its effects from all angles, rather than only through the captured image on an LCD screen as with flash.

Any discussion of continuous studio lighting will overlap with much of what we discussed in the chapter on artificial light, as these lights are incandescent, fluorescent, or vapor discharge. The difference, of course, is that they are purpose-built for photography, and their color temperatures are precisely calibrated to emit a specific, predictable kind of light.

← Light banks

Long fluorescent tubes are well suited to creating large light banks for even distribution of light. They are commonly used in product photography where the product needs to stand alone, without any obvious or distracting shadows. While large-scale equipment like this is probably out of your budget, it's worth seeing how the pros work so that you can mimic their results with the gear you have on hand. A sheet pulled tight across a large window would function quite the same—so long as their is adequate sunlight.

Incandescent

Simple, rugged, and foolproof, incandescent studio lights are the easiest continuous light sources to work with. Their continuous spectrum means they can be balanced to other light sources with the use of filters, and are easily shaped by accessories to offer either soft, diffuse light or a tight, focused beam. However, they do have a significant and even dangerous drawback: heat. On the surface, this can simply be an inconvenience. Portrait subjects can start sweating, makeup can melt, and a long day's work in the studio can get quite uncomfortable. Beyond that, their heat can gradually yellow and char an otherwise white surface like a painted wall; and if extreme caution isn't taken in their setup, they can even set fire to any accessories attached to them. Toward this end, if you plan on working with extensive incandescent setups, safety is essential: Keep fire extinguishers handy, and in a studio, make sure all fire escapes are accessible.

Fluorescent

If designed with photography in mind, fluorescent lamps will include coatings matched to the spectral sensitivities of digital imaging sensors that cast precise, easily captured color temperatures. The long tubes commonly used for this type of light are also ideal for light banks that evenly illuminate a large area—often used for still life and product photography. To augment this natural tendency toward diffusion, concave reflectors can be placed behind a row of lamps to further the spread of light. The other side of the coin, of course, is that fluorescents are not easily shaped into focused, directional light. And while they are much more energy-efficient than incandescents, they tend to cost more up-front—particularly replacement lamps. Finally, they do not emit a great deal of heat, and so the associated worries of dissipation and fire need not be a major concern.

HMI

Vapor discharge lamps designed for photography use Hydrargyrum Medium-arc Iodide (HMI) as the metal salt, and the resulting light is a clean, pure white. This is ideal for balancing with ambient daylight—such that these lights are commonly referred to in the industry as Daylight lamps. They can be powerful enough to use outdoors in direct sunlight, and you needn't worry about their heat dissipation. The nature of their technology, however, requires that they are bulky and cumbersome—not to mention expensive.

Lighting Accessories

A studio light source, be it flash or continuous, is just the beginning of light in a studio scene. Between the source and the subject, that light can be manipulated in any number of ways. On page 43, we discussed using reflectors to bounce natural light and fill in shadows. In the studio, large, flat reflectors can be used similarly—in fact, the typical studio is painted pure white, allowing the wall, floor, or ceiling to be used as a reflector. When it comes to studio lighting accessories, however, reflectors take on a different role and allow you to work with a great degree of precision.

 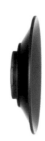

↑ Reflector shapes
Each reflector, mounted to the front of a light source, determines a distinct angle at which that light will shine on the subject.

↓ Parabolic reflectors
The parabolic dish works a bit differently from other reflectors, allowing the light source itself to be moved closer to or farther from the center of the shape. The quality of the light changes according to its position.

Reflector Dishes

Attached directly to continuous light sources, a reflector dish molds the light at its source, preventing it from spilling over at the edges and focusing its output at a definitive angle (commonly called "spill kill"). The reflective inner surface augments the strength of that light, depending on its color—shiny silver produces a strong, hard light; matte white weakens the light, making it softer.

Umbrellas

Commonly seen in portrait studios, umbrellas use the same principle as bounce light discussed on page 94. The light source is pointed away from the subject itself and into the parabola of the umbrella interior, which reflects that light back toward the subject across a wider area. The result is a softer light, flattering for portraits. The light also takes on the qualities of the material used in the umbrella interior— silver for the strongest light, golden for warmth, or white for the softest effect. And just like a rain umbrella, these accessories collapse for easy storage.

↓ Not meant for rainy weather
Extremely effective at creating soft, flattering light, umbrellas are easy to work with, as their light is diffuse enough that precise positioning isn't as necessary as with other point-source lighting equipment. They do require a tripod on which to be mounted.

Softboxes

These accessories catch the light from a single-point source within a confined, reflective space, and then transmit it out across a defined surface. They can be quite small, appearing rather like a household shelf lamp, or extremely large, becoming the primary light source and mimicking the powerful but soft, diffuse light of a sunlit window. They can also have any number of materials attached to their front, which will impart certain characteristics or textures to the light as it shines on a subject.

← **Softbox sizes**
The depth of the softbox affects the angle of light emitted, with deeper boxes casting a narrower, more focused light. Though these pieces of equipment look almost comically bulky, they are in fact extremely lightweight and collapsible.

↑ **Bigger is better**
As you might expect, the bigger the diffuser, the more effective it is at spreading out a nice, even light.

→ **Narrow your flash beam**
The snoot pictured here is mounted to a flash unit, but they are also available for continuous light sources of all shapes and sizes. This particular model has an extendable arm, allowing you to control the focus of the beam without having to reposition the flash itself.

External Flash Unit Diffuser

A trademark of the paparazzi, these portable accessories attach to an external flash unit to soften the harsh, directional light characteristic of this light source. They still allow the flash to be rotated, and can thereby be used in conjunction with bounce light. While available in a variety of shapes and sizes, the most effective ones are quite bulky, and can be cumbersome to work with in tight spaces.

Snoots

A funny name for a funny-looking piece of gear, the snoot turns your light source into a spotlight, funnelling its light into a narrow beam.

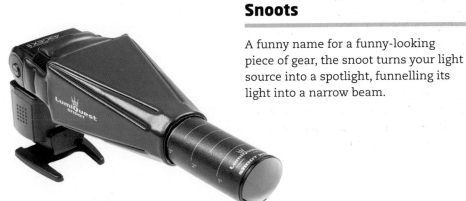

© LumiQuest

Home Studio

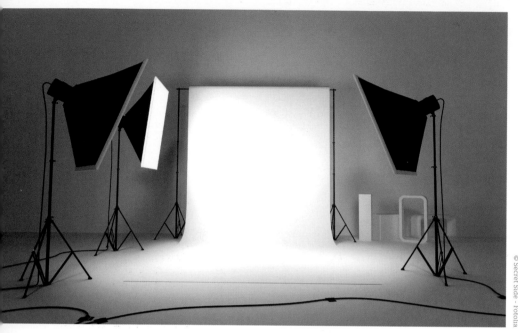

← A Typical Studio

It may surprise you how easily you can mimic the results of a giant studio with tens of thousands of dollars worth of high-end equipment. This studio, for instance, is really quite simple: nothing but white, nonreflective surfaces and a few softboxes. Replace the whitewash paint with some bedsheets, set it up next to a northern window (which has the most even light throughout the day), and you're most of the way there.

A professional studio can easily cost a small fortune to set up, but they are designed to accommodate any possible assignment and spare no expense in the process. Setting up a small studio in your home need not be such a colossal task, nor is it prohibitively expensive. It is entirely possible to build a highly functional studio on a budget, which will provide you with a great base from which to experiment.

Keep it Simple

It's easy to get lost in the many options for equipment and setup, but when designing your own home studio never lose sight of the most important issue: control of the light. Studios are all about total creative control, and managing the variables that affect the light is key. Windows are great for natural sunlight, but they should have black curtains to limit their effect. Any colored surface will contribute a color cast as light reflects off of it; but if you're not feeling up to a big paint job, white bedsheets can go a long way—just be sure they are stretched tight enough to prevent any textural shadows. Overhead lighting can be useful for setting up a shot, but be sure that when it is turned off you still have enough light in which to work. Finally, keep a keen eye out for any other variables that may exist—for instance, even the breeze from a ceiling fan, while irrelevant to the light, can disturb a delicate still life and introduce motion blur.

Improvise

Before you run out and spend your paycheck on high-end gear, it can be a valuable experience to assemble a photo studio with items on hand. Household tungsten lamps can be fitted with quality bulbs of varying intensities to become continuous incandescent light sources—though if you are using multiple lamps, be sure the bulbs are of the same make and model. Bedsheets can be backdrops, and posterboard can be used for reflectors— particularly if you wrap one side with aluminum foil. Experiment with what you have available, and see what you can achieve—but of course, safety always comes first. Don't get anything too close to your lamps, and if anything starts feeling too warm, cut the power and let everything cool off.

Equipment

When you have experimented with improvised setups enough and are ready to commit to buying your own professional equipment, start small and make sure you make the most of each piece of gear. If you feel comfortable with the nuances and calculations involved in flash photography, external flash units are a good place to start. For one, they are useful out of the studio as well, as they can be mounted to the camera and taken on the road with ease. Also, many DSLRs act as a fully functional control panel, allowing control of multiple flashes by infrared or radio waves. You will still need to acquire quality tripods with flash mounts, of course, as well as some diffuser accessories.

If you plan on making your home studio a dedicated photographic space, however, it pays to take the dive and start purchasing professional continuous lights. As with most things, you get what you pay for in the world of photographic lighting, so the particular type of lamps can correspond to your budget. Two lamps is a good place to start, as together they offer you an enormous range of possible lighting setups. You will also want a way to diffuse them, so at least one softbox or umbrella will let you achieve any soft light required by your subjects. A roll of black cinefoil is also an inexpensive and extremely versatile tool that will let you mold the light exactly the way you want it. Cinefoil is made of completely nonreflective material, and feels rather like aluminum foil, meaning it can be bent and formed into any shape you require. Roll it into a simple tube, attach it to the end of your flash, and you've got a

↑ **Still-life setup**
Still lifes are an excellent subject to shoot when you're first starting your studio, as inanimate objects are considerably more patient than models in costume and makeup. This simple setup uses a large softbox positioned above and to the left of the figurine, which is then balanced by placing a small reflecting card very close on the right.

← **Finished miniature**
After some light post-production work, the finished shot is worthy of inclusion in any fine-art catalog.

snoot. Mount four separate sheets on the sides of your continuous lamp, and you've got barndoors. It can also serve as an ideal backdrop, as you needn't worry about any distracting reflections.

Studio Shots on a Budget

With any luck, the previous pages have taken studio setups from an intimidating and expensive professional luxury down to something that is both approachable and achievable in your own home. With minimal equipment, you should be able to get high-quality shots that show off your understanding of light sources, their accessories, and their proper placement for various styles of photography. The point of this challenge is to control your light—the results may be an obviously spot-lit shot, or they may mimic the soft light of an overcast day for a clean representation of your subject.

→ **A friendly model**
A cooperative model and a clean backdrop is all you need to start exploring studio portraiture.

A creative still life is a good starting point. If thousands of ebay entrepreneurs can show off their wares with simple point-and-shoots, imagine how much better your shots will be if you take the time to diffuse the light properly, and show off every angle of your subject.

Challenge Checklist

→ If you're setting up a still-life shot, you have all the time in the world. Experiment, test, evaluate, and repeat.

→ If you find yourself in need of a particular accessory that you don't have on hand, try improvising using the advice on the previous pages.

→ If your camera has a Live View function, the slow-paced studio is an excellent place to use it, as you can evaluate the histogram in real time, and observe different white balance settings in advance.

Review

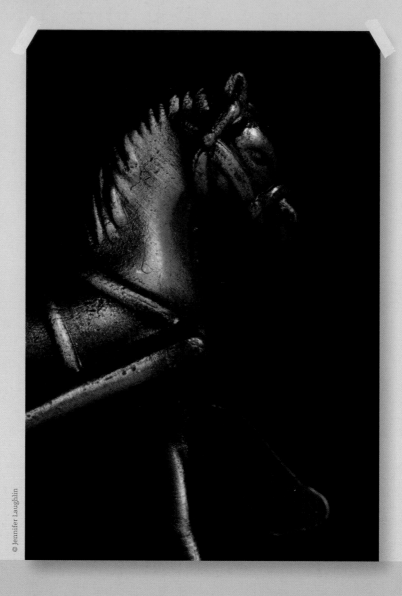

© Jennifer Laughlin

For this shot I used a hot light with a diffuser attached, and reflector card to fill in the shadows. The figurine was held upright by a stand (out of frame) with a black backdrop behind it.
Jennifer Laughlin

Nice work with a minimal setup—the diffused light shows off the rounded contours of the figurine, and the black backdrop makes it pop.
Michael Freeman

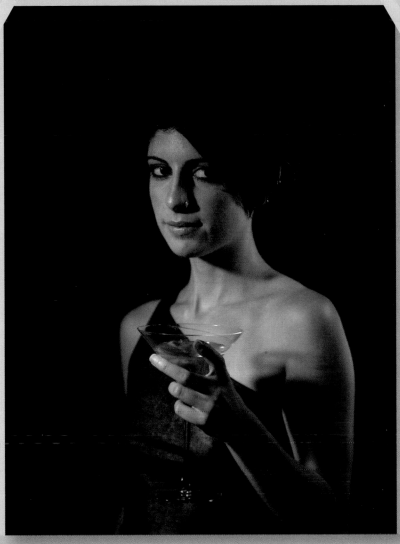

© Kelly Jo Garner

A shot from the *Martini Project: Beautiful Women, Beautiful Drinks* series. I had a cheap kit lighting set with a continuous light and softbox, and a flat sheet to use as a backdrop. The gin for the martinis cost more than the setup!

Kelly Jo Garner

Good balance between main and secondary lights, though the difference in color temperatures is a bit distracting. I wonder if stronger use of your lighting could have emphasized the martini glass—by having it positioned against a solid area of color, or by letting it cast a definite shadow on the model's bare shoulder.

Michael Freeman

Positioning the Light

With a thorough understanding of all the different sources of photographic light, you can now consider their use in composing a shot. No longer limited to a single light source (be it a built-in flash or the sun in the sky), you must think in a three-dimensional, comprehensive manner, and choose both the angle and intensity of the light as it falls on every side of your subject. Using the diagram on the opposite page, you can imagine an infinite variety of lighting setups. The key is to decide which is best for the scene you want to create. Do you want to accentuate texture and add drama with a strong side light? Or do you want to completely eliminate shadows by combining diffuse frontal light and backlight, making your subject appear free floating and weightless? While experimentation is essential, and can indeed be a lot of fun, you will save yourself hours of work if you decide in advance what you want to achieve, and then calculate an appropriate approach to that end result.

Frontal Light

We know from our discussion of built-in flash that this is the least flattering angle of light, chiefly because the resulting lack of shadows means our eyes have no reference for depth, and the subject appears flat and dull. However, frontal light is invaluable in combination with secondary or tertiary light sources, wherein its obvious directionality makes it easy to adjust in order to balance the other lights.

Three-Quarter Light

The most common lighting position of all, three-quarter light has the source slightly above and to the side of the camera. From this angle, light can lend a sense of depth without casting obvious shadows. Building on this fundamental setup, you could add a second light at a three-quarter angle on the opposite side of the camera, and adjust the intensity of each to achieve a precise balance. Then you could add a reflector underneath the front of the subject to bounce up the light from the two sources, filling in any unwanted shadows.

Right-Angled Light

Light shining directly on the side of your subject will cast shadows across the frame, unless it is balanced by a stronger frontal light—excellent for revealing textures, but distracting in most portraits.

Backlight

Alone, backlight gives you silhouettes and edge lighting. But balanced with a frontal light, backlighting can give your subject a well rounded appearance, excellent for emphasizing contours.

← Classic portrait
The three-quarter setup described above was used for this portrait subject. By making the right light slightly stronger than the left, a hint of shadow is cast across the left side of her face—just enough to add a sense of depth.

© Salim October

↓ Lighting in the round

This diagram can help you imagine the various approaches available as you decide how to light a subject (here, a person's head and shoulders). Keep in mind that as you move around the vertical and horizontal arcs, in reality your lamps can be placed closer to or farther from the subject, affecting their output in accordance with the inverse square law. You may even keep this diagram in mind as you photograph outdoors, imagining the blue vertical arc as the sun's path across the sky, and your camera position relative to the subject falling somewhere along the yellow horizontal arc. Of course, in the studio, the blue arc continues underneath the subject as well.

90° Vertical

90° Horizontal

180° Horizontal

Subject

Vertical lamp movement

0° Horizontal
0° Vertical

270° Horizontal

Horizontal lamp movement

Camera

Possible reflector positions

Light a Portrait

↓ An engaged subject
What was in fact a carefully set up outdoor shot will appear candid and spontaneous with the judicious use of diffusers and fill flash.

We've discussed portraiture in several places already, and you may have taken a portrait or two for some of the previous challenges. This challenge, however, is all about specifically setting up and controlling the light for a portrait. This may not necessarily mean you need to build a studio and coordinate multiple different light sources—you may want to use the soft light of a northern window to naturally light your subject. The point is to think specifically about light in terms of portraiture, and to position your subject in that light so that they are captured flatteringly.

→ **Staring off to the side**

Portraiture is just as much about positioning your model as it is about positioning your lights—indeed, what was a side light becomes a frontal or three-quarter light as soon as your model turns their head.

Challenge Checklist

→ First off, you'll need a portrait model. With any luck they'll be patient while you experiment with different angles and adjust your lights.

→ Keep your model comfortable and at ease while you are working. Conversation goes a long way toward making them relax, and a relaxed model will always photograph better than a nervous one.

→ While diffuse light is usually the name of the game, if you feel the urge to try out some more dramatic lighting— such as a strong side light for a dramatic shadow—indulge that creative instinct.

Review

©Adam Graetz

I used a Nikon SB-800 strobe off to camera left without a diffuser to create some very dramatic lighting that would accentuate the model's left half, creating a stark, vertical line to divide the frame.

Adam Graetz

While going against normal, flattering portrait lighting, it works because of the urban setting. Definitely an edgy and striking shot—supported by the composition, with the subject's face at the vanishing point of several lines from different angles.

Michael Freeman

© Jennifer Laughlin

This photo was taken at a fruit/veggie stand late in the afternoon with a Nikon D300 and overcast skies as my only light. I used a giant reflector card to get the fill on her face.

Jennifer Laughlin

A good decision to break out the big reflectors, to avoid the usually drab effect from an overcast day. It takes a bit more effort and planning, but it's well worth it for reliable results, like this pleasant portrait.

Michael Freeman

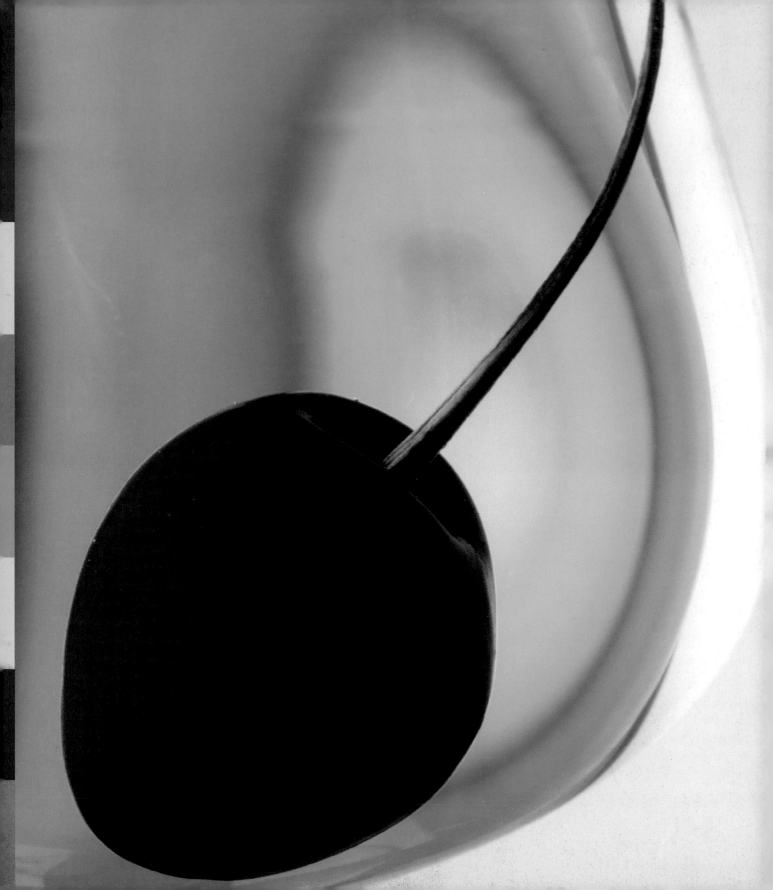

Lighting Styles

Thus far, we've discussed light as it is either found in natural and artificial environments, or created in the studio. From these foundations and with a thorough understanding of all the different characteristics of the myriad light sources available to your photography, now you must step back and consider light not just as a quantifiable, measurable, and manipulatable object, but also as a style in itself.

As always, certain styles of light are more appropriate to certain subjects than others, so you must decide ahead of time what you wish to communicate in your photograph and work up from there. If you are shooting close-ups of fine-art objects for a catalogue, you probably want the light to get out of the way and simply show off the subject itself—dark shadows or high contrast with lots of flare and reflections would only serve to distract the viewer from what is important. On the other hand, there are situations wherein the light itself is what is important, and you need merely frame the composition and strike a balance between highlights and shadows that makes for a dynamic and graphic image, regardless of the underlying subject.

These considerations may take place on the drawing board in your studio, or at the spur of the moment when a certain lighting scenario catches your eye on the street. Regardless, what matters is that you see the bigger picture—not necessarily the picture you are about to take, but the conditions and possibilities offered to you by the various lighting styles at your disposal.

Soft Light

Be it from sunlight diffusing through clouds, flash bouncing off an umbrella, or multiple incandescent lamps evenly illuminating an interior space, soft light is characterized by its lack of obvious directionality and the evenness with which it illuminates a subject. Indeed, soft light is most effective when it is hardly noticeable at all—which is to say, when the light itself is not an essential compositional element of the photograph. First, let's look at how light is transformed from hard to soft, and then explore the right times to use it.

Light almost always originates from a point-source, meaning there is a single point from which the light radiates outwards. Because of the nature of light to travel in a straight line, this means that the direction from which the light is shining becomes obvious as it falls onto a subject; the shadows will all orient at the same angle, and the viewer's mind is keenly able to reconstruct where the light originated. Decreasing this obviousness so the light seems to come from all around is the essence of soft light.

To achieve this, the simplest method is to introduce distance between the light source and the subject. As the light travels across a greater distance, it has more time to spread out. You can observe this in large interior spaces, where a strong point-source light hanging from a tall ceiling can evenly illuminate the area below it. However, each individual beam of light is still traveling in a straight line; it can't turn around a corner to shine into crevices or give a rounded quality to smooth contours.

And this is why we have spoken so much of diffusers and reflectors throughout this book. Introducing a translucent material (a diffuser) between the light source and the subject will scatter the vectors of light, such that they are no longer all radiating out from a central point. What was a series of straight lines becomes a jumble of different angles of light, some of which can illuminate one side of the subject, while others from a different angle can light the other side. In effect, the light can now turn those corners and fill in every shadow, resulting in an evenly lit subject. Reflectors, working from the other side of the subject, achieve the same thing—reflecting the light so it can shine into spaces that would otherwise fall into shadow.

© Saruri

← Diffuse close-up

With no harsh shadows to give obvious directionality to the light source, this bundle of flowers seems to float effortlessly, and at this close distance one can imagine that they go on endlessly outside of the frame.

It is also worth noting that, in terms of exposure, soft light is much easier to work with—provided it is properly set up for the scene. By its nature, this lighting style is low in contrast, meaning you have quite a bit of room to maneuver between the highlights and the shadows. It is still important to make sure that your mid-tones fall at the center of your histogram, but you needn't worry too much about the dynamic range exceeding the capabilities of your sensor.

Soft Light for Portraits

When you remember a human face, you are recalling its shape, the position of its features, its complexion, and so on. The image in your mind does not include deep shadows under the eyes, or a single bright beam of light across a forehead, because such elements are not an inherent part of the face itself. Generally speaking, most portraiture seeks an idealized representation of the subject, in which the person's face is allowed to speak for itself. You would no more let a distracting shadow obscure half of their face than you would let them wear a ski mask for the shoot. It's all about showing them in the best possible light, which for portraiture, is soft light.

Because it can shine around corners and doesn't accentuate hard edges, soft light hides wrinkles and helps your subject appear if not younger, then at least less weathered and aged. Likewise, you must position and diffuse your lights such that their eye sockets are just as illuminated as the rest of their face, and their chin isn't casting shadows down along their neck and chest.

© Darya Polunina

↑ Simple softbox setup
This classic head-and-shoulders portrait, softly lit from the right by a softbox, just barely indicates the direction of the light with subtle shadowing on the left side of the face—just enough to add depth to the image without obscuring the face or becoming distracting.

Enveloping Light

Taken to the extreme, soft light can be set up to completely surround a subject, bathing it in total, diffuse light that fills in every nook and cranny, eliminates every shadow, and makes the subject appear lightweight and buoyant. This enveloping light is a particular style, and not necessarily suitable for all subjects. For instance, you may think that if soft light is ideal for portraits, then completely suffusing your subject in an abundance of soft light is all the better; but that can too easily result in overly surreal and unrealistic portraits. Keep in mind that enveloping light is rarely found in nature, and your eye will recognize it as exceptional.

That said, there are many cases when enveloping light benefits a subject, and it is a useful tool when dealing with particular lighting problems. For instance, if you are photographing a highly reflective object, it may be impossible to set up the shot without having studio equipment appearing in the frame, reflected off the object's surface. For this reason, enveloping light is often used for still lifes and close-up shots.

The easiest way to cover a subject from all angles with soft, diffuse light is to use a light tent. These lighting accessories are a simple affair, and involve surrounding the subject with a diffusing material of some sort—white fabric is the most common, but any translucent material will do. Arranged correctly, the light tent will diffuse any light coming from outside the frame, meaning you can use point-source

lights and move them freely around the set until the desired effect is achieved. The lights must be positioned far enough away that they do not create perceptible hot spots on the tent's surfaces, but still close enough to give enough illumination for an adequate exposure. This is particularly important with macro and close-up photography, which often use narrow apertures for an abundance of depth of field, at the expense of available light. Additionally, once the light is diffused inside the tent, it continues to reflect across all the interior surfaces, further evening the spread of light on the enclosed subject.

←↓ Home- vs ready-made
The definition of a light tent is not strict; any structure will do so long as it results in a complete diffusion of light from all angles in its interior. The portable light tent below, designed by Creative Light, collapses down for easy transport into the field, and comes with a selection of translucent backdrops that can attach to the interior with Velcro.

© Creative Light

Light tents aren't limited to studio work, however. They can also be set up in the field, where they can diffuse otherwise harsh sunlight. This is particularly suitable for capturing small insects or flower specimens as you encounter them in the wild. By surrounding them in artificial material, they will lose their sense of environment; but the effect can also evoke the classic look of natural history illustration, with its clean, idyllic portrayal cast against pure white. Light tents in the field may also simply be a necessity for capturing subjects that you could not otherwise move into the studio—for instance, many gardens don't look kindly on you plucking out their prized orchids or stealing their wildlife.

Improvised light tents are simple enough, you need only a clean white sheet and a stand from which to hang it. Circle the sheet around the subject, and poke your camera through the slit where the two ends meet. However, for best results that avoid any textured surfaces, a dedicated light tent is the way to go. These come in a variety of sizes, and are collapsible, making them much easier to take in the field.

↓ Precious stones

These gems, shot from directly above and scattered across a white velvet background, still indicate a slight directionality of the diffused light coming from the upper left, but only just enough to give them a sense of place and show off their polished surfaces with a slight glare. The velvet itself was dense enough to soften and absorb most of the shadows.

→ No reflections

Anything less than completely encircling this gold bar with diffuse light would have resulted in clearly visible reflections of the surrounding studio equipment in its shiny, polished surface. For contrast, a black backdrop was used at the base of the light tent.

Bathe your Subject in Soft Light

Challenge

↓ Dynamic B&W
High-key enveloping light is another lighting style that is well suited to black and white, as your eye doesn't mind and even expects to see large areas of uniform white.

For this challenge, you really want to go over the top with soft light, and envelope your subject in it as much as you can. This will lend itself well to the use of a light tent, discussed on the previous pages, which will let you evenly distribute light all around your subject without hassling with a number of different diffusers and reflectors.

However, in the right conditions, you may be able to find an abundance of available soft light out in the field. Wherever you find you soft light, use it to show off the subject in all its glory, completely illuminating every surface and eliminating as many shadows as possible.

→ **A light touch**
Food dishes often benefit from a full, enveloping light, as there is something unappetizing about heavy shadows falling across your plate.

Challenge Checklist

→ Diffusers, reflectors, and/or a light tent will help with still-life subjects, and you should try to highlight the natural colors, shapes, and contours.

→ You may try for an ethereal portrait—much like the previous challenge but striving for even more diffusion of light.

→ Or you can try thinking big and search out a full landscape on a heavily overcast day, perhaps using mist or fog to further diffuse the light and add a mystical quality to your image.

Review

© Jennifer Laughlin

I used three hot lights with magenta gels to light the white wall for the background. I clipped the rhubarb at the end with a backdrop clip to make it stand up. After setting this up there was one hot light with a diffuser placed to the right front of the subject. White reflector cards were used to achieve the even lighting.
Jennifer Laughlin

The minimal shadows work well here, giving just a hint of modeling to the (distressed!) rhubarb. I also like the classical counter shading between the rhubarb and the background.
Michael Freeman

© Sven Thierie

This was an improvised macro shot. I found this dead but perfectly intact butterfly on a particularly cloudy day, scooped it up on a sheet of white paper, and photographed it right there on the sidewalk. There's still a bit of shadow along the left side, but considering the quick setup, I think I got pretty lucky with this one!

Sven Thierie

A good testament to the usefulness of the soft light cast by an overcast sky—these results are pretty close to what you'd get with a light tent in a studio. And the soft shadow helps lift the butterfly.

Michael Freeman

Hard Light

If soft light is the absence of obvious lighting effects, it follows that hard light establishes in a photograph a prominent and palpable presence of light in the scene. This is when light takes on a material quality, either in its strong reaction to a subject or as a compositional element in itself.

Hard light generally indicates a lack of obstruction between the light source and the subject—no clouds, no diffusion screens, and no reflective surfaces bouncing the light around. Light strikes the subject at a definite angle, indicated by shadows falling in a common direction. Thus, it becomes

clear that hard light is just as dependent on the subject as it is on the source itself, for if the subject offers no edges or contours to cast shadows, there is no way for a photograph to indicate the directionality of the light.

By definition, hard light is going to increase the contrast of a photograph. Some areas of the frame will be brightly lit, with others falling into dark shadows. Careful calculation of proper exposure is therefore all the more important, as the higher dynamic range means you must keep a close eye on the histogram to ensure that your sensor captures detail throughout the full range of light

intensities. On the other hand, you can make a creative decision to accentuate this contrast by completely losing detail in the shadows or highlights (or both). We discuss this chiaroscuro approach in the following pages.

Finally, because hard light gives the eye more clues as to the direction of the light source, it also gives a photograph a corresponding sense of time and place. We discussed the flattering aspects of golden light on pages 54–55. Whether you realize it or not, you recognize long shadows as occurring early or late in the day.

→ Georgian lighting
Architecture often benefits from a hard light, where it throws structural elements into harsh relief and accents the design of the building. For instance, the circular orientation of the Circus in Bath, England is accentuated here, where hard, angled light progressively falls into shadow as the building curves around up and to the left.

© Frank Gallaugher

Graphic Design

By emphasizing hard edges and bringing shapes into stark relief, hard light gives you the tools for creating photographs that emphasize form and design over content—meaning they are less about an accurate rendition of the subject itself, and more about lines, shapes, colors, and contrast. Letting the geometry of the composition take precedence over its underlying subject can give a surprising, exciting, and energetic feel to your photography.

This style requires you to see past the face value of a scene—to deconstruct that scene, as it were, into its constituent parts. Where a casual observer may simply see the side of a skyscraper, the graphic stylist sees a line of repeating squares, angled at a diagonal from the low perspective, with beams of light cutting through a neighboring structure and punctuating the building's surface with negative space. Telephoto lenses often help with these kinds of photographs, as they can isolate particular elements out of their natural surroundings, which can assist in discarding the material subject's preeminence. Seeing the world this way can become quite addictive, and while it is hardly appropriate for every subject, it gives you the chance to infuse even the commonplace with a dynamic and robust style.

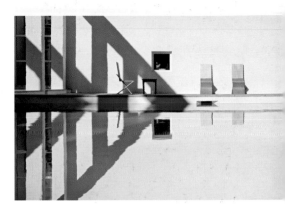

↑ Shapes, lines, and shadows
In viewing this image, your eyes register the design elements first: obvious diagonals, permeated and reinforced by verticals, all reflected symmetrically across a horizontal axis. These elements were emphasized in post-production by increasing contrast and clarity. Only secondarily does the reality of the subject itself come into play.

Gobos for Patterns

You can add a graphic or textural quality to the light yourself by using a type of stencil called a gobo, which stands for GOes Before Optics (they are alternately called cookies or flags). These patterned screens throw a certain shadow onto your subject, depending on their design. They occur naturally as well—you can consider the repeating pattern of lines cast by blinds on a window to be a gobo effect. Gobos can be used for obvious graphic design elements, where the shape taken on by the light becomes an object in itself; or they can impart a less obvious texture to the light, which will spread out across the subject, taking on its curves and rounding off its edges.

← Texture designs
A small sample of different gobo designs. These can be small enough to fit on the end of a flash unit, or large enough to cover a window.

↑ Molten light
There are two gobos at work here: the window frame is casting the strong, crisscrossed lines diagonally across the frame; and the imperfections in the glass are changing the quality of the light itself into a wavy, fluid pattern.

Chiaroscuro

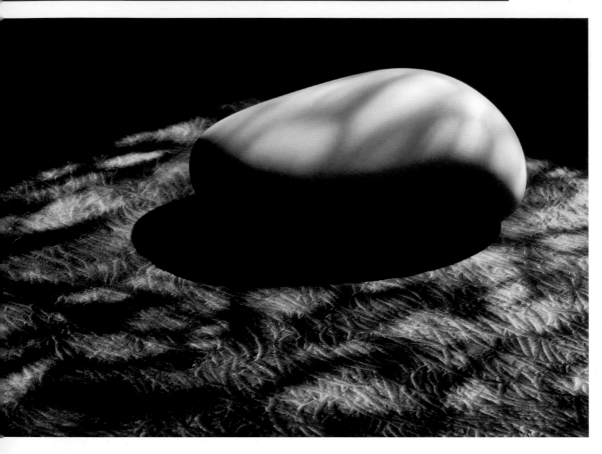

← **Shadow play**
Black-and-white photography lends itself well to the chiaroscuro lighting style, as your eye concentrates only on the subtleties of gradation from light to dark without getting distracted by color.

A beautiful Italian word for a beautiful lighting style, chiaroscuro literally means light-dark. It is a Renaissance art term, pioneered by the painter Caravaggio, in which shapes are created not by outlining their edges, but by using subtle gradations of light and shade to create rounded, three-dimensional forms. By nature of its high contrast, it is a type of hard light, but a very delicately implemented one. A single, point-source hard light will fall off too sharply at the edges of a shape, and the definitive lines it casts are not the defining characteristic of this lighting style.

Rather, chiaroscuro is something of a balance between hard and soft light. It must be hard enough to cast deep shadows, in which you may choose to completely lose all detail and create large blocks of black, out of which the subject rises. And it must be just soft enough that the edges and contours of the subject are apparent, with the light gradually falling from the highlights off into the shadows.

Mood and drama are inseparable from chiaroscuro lighting. An otherwise mundane still life of a bowl of fruit on a table will, when set against a pure-

black backdrop with obvious side lighting, take on a timeless and painterly quality. It can also contribute a sense of dread and foreboding, as the mind is forced to speculate as to what may lurk in the deep shadows that constitute a large part of the composition. Consider the lighting style typical of film noir, for instance, where the cynical and deviant themes of crime drama were illustrated by consistent chiaroscuro lighting, making a half-lit character appear shifty and untrustworthy, and the shadows cast across a room insinuate foul play and hidden agendas.

Chiaroscuro Lighting Setups

In the studio, chiaroscuro lighting is relatively simple to achieve, as it embraces the contrast and deep shadows that other lighting styles seek to eliminate by employing copious diffusers, reflectors, and multiple light sources.

For the simplest setup, place your subject against a black backdrop, and light it from a three-quarter angle with a strong point-source lamp with a diffuser attached. The light will reach the backdrop at different distances, creating a gradation from light to dark against which your subject can stand out.

Depending on the effect you want to achieve, you may rotate the backdrop so it isn't perpendicular to the camera, which will create a gradient along the length of the background itself.

Metering a chiaroscuro setup can be tricky, given the abundance of contrast. Spot metering off the highlights is the simplest approach, provided you want to lose detail in the shadows. That said, it is often a safer bet to capture as much detail as possible throughout the dynamic range of the scene, as shadows and highlights can always be pushed down or blown out in post-production. Try spot metering first off a shadow, then off a highlight area, and use your camera's exposure readout to find a happy medium between those two extremes.

← Dark profile
Chiaroscuro works well with profiles, and the setup for this shot couldn't be simpler: A single light source shining from upper left, and a distant, pure-black background that's not picking up any detail at all. The weathered, textured face and beard of the subject suits the lighting style, giving lots of detail in which to see the progressive darkening of tones as the light falls off.

↓ Emerging from the dark
To capture chiaroscuro lighting outside of the studio, keep an eye out for single light sources in otherwise dark environments. This painter was working by a small spotlight during an intimate music concert, and by spot metering off the canvas, the surrounding falls off sharply into shadow.

Kick It Up a Notch with Hard Light

↓ Dune shadows
The dynamic range between the sun-facing right side of the dunes and the shadows on the left required a careful exposure, with one eye firmly on the histogram.

For this challenge, you should embrace a strong, directional light source and feature its effects at the forefront of your photo. As you've seen on the previous pages, there are a few different approaches to making the light a preeminent element of the image—you can zoom in on particular detail and compose the shot so that it has an obvious graphic quality, or you can spotlight a subject and experiment with the delicate craft of chiaroscuro lighting. If you have the time and control, try cutting out your own gobos and capturing their effects as their shadows fall on a particular subject.

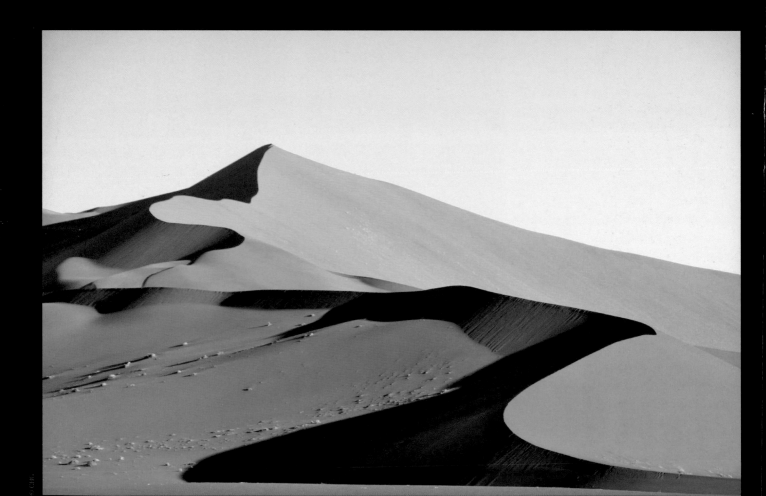

→ **Salisbury in the sun**
On angular subjects like buildings and towers, you'll easily see the contrast created by hard light, which fully illuminates one side while letting the other fall into shadow. Rather than battle this effect, I even upped the contrast in post-production to exaggerate it a bit, as it adds to the grandiosity of this subject.

Challenge Checklist

→ You'll need to start, obviously, with a hard light source. If you're setting up the shot, this can be a straightforward lamp of any variety. Otherwise, mid-morning and late afternoon will give you plenty of long, dramatic shadows to play around with.

→ Watch your exposure, as always, but don't be afraid to let some of your shadows block up into pure black if that's what you envision.

→ This might be an excellent time to try your hand at black-and-white photography, as it speaks completely through light alone and doesn't let your viewers (or you) get distracted by irrelevant color information.

Review

© Kelly Jo Garner

On my second trip to Chicago, I was fortunate enough to stay with an old university friend in the Boystown district. His building was luminous in the early morning light when I snapped this shot.

Kelly Jo Garner

Shooting at this angle to the light makes the most of the shadows and catches some reflection from the brickwork, enhancing contrast. I'd suggest cropping the top to lose the branches and capitalize on your treatment of the architecture.

Michael Freeman

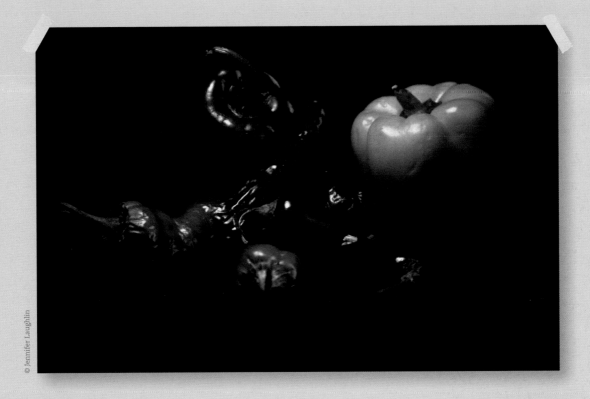

© Jennifer Laughlin

This photograph was shot using a "painting with light" technique. Using only a flashlight, I set up a shot of these vegetables, turned the lights off, and "painted" the subject with a flashlight.
Jennifer Laughlin

A successful experiment. Lighting painting is definitely one technique that you can expect to deliver chiaroscuro. Digital cameras certainly help by giving instant feedback, as you're literally working in the dark and the results can otherwise be difficult to predict.
Michael Freeman

Backlighting

We've discussed backlighting as it relates to shooting into the sun on pages 48–49, and many of the same principles apply to backlit studio setups—the difference being that the light itself is unlikely to be the subject (rich, vivid sunsets are basically inimicable in the studio), so you'll be combating underexposure with careful use of spot metering, exposure compensation, or shadow fill. Toward that end, delicate use of backlighting will emphasize the shape of the subject, giving it clear, defined edges with a slight glow.

A typical backlighting setup will diffuse the light through an appropriately sized backdrop in between the lamps and the subject. Depending on the size of your subject, this properly illuminating the backdrop can require some skill (or simple trial and error) to perfect, as it is no easy task to completely illuminate a large area equally from one side to the other. Broad-source lights are the most useful kind, such as fluorescent light banks or large softboxes. Because the diffusing backdrop is in frame, you must make sure that it is completely free of wrinkles or other texture, and spotlessly clean. How fastidious you must be about the cleanliness of the backdrop depends on its distance from the subject—if it is far enough back, and the depth of field is sufficiently limited, any imperfections will be imperceptible amidst the out-of-focus flood of bright, white light.

To ensure even illumination across the full expanse of the background, you can either increase the thickness of the diffusing backdrop or spread out the light at its source—both of which will decrease the intensity of the light, so a close eye must be kept on the exposure. A single lamp shining directly at the camera will evenly light the backdrop, as its light radiates out from all directions equally; but it may have to be positioned so far back that it no longer is bright enough. Two or more lamps will solve the problem of brightness, but then they must be perfectly balanced to make sure one is not illuminating the backdrop more than the other. Crossing their beams is therefore a good approach, with each lamp pointed toward the far end of the backdrop. Handheld light meters are useful here, as you can measure each side of the backdrop independently to make sure they are giving identical exposures across the frame.

→ **Furoshiki**
For this photo, a translucent table was covered by white, textureless fabric and lit from underneath and behind, with the camera positioned above and shooting down. The result is similar to the enveloping light discussed on pages 122–123, but leaving enough shadows on the top of the subject to illustrate the delicate folds of a furoshiki, or Japanese gift-wrapping cloth.

Transparency & Translucency

A material is transparent if you can still discern shapes and objects while looking through it (the object on the other side of the material is *apparent*). Translucent materials, on the other hand, will likewise transmit light, but objects seen through them will have their shapes blurred and obscured, making them glow. Transparent and translucent subjects require their own lighting styles to make the most of their unique properties, and are well suited to backlighting.

↙ Light through a liquid
Most liquids are transparent or at least translucent, and their fluid properties respond well to backlighting. Here, the colored reflections on the table behind the martini glass are being picked up in the drink, pulling that light up to the top of the frame and keeping the image from being too dark.

© Benjamin Haas

← Translucent jellyfish
Combined with their fluidic movements and amorphous shapes, the translucency of most jellyfish makes for stunning backlit images. Many aquariums will have a light source positioned in the tank to allow you to peer through the these odd creatures and capture their inner workings—almost like an x-ray.

← Evening
Silhouettes are a classic use of backlighting, and this image combines a clearly shadowed main subject with a luminescent cloth, glowing yellow from the light behind. Notice also how the folds and creases of the fabric are emphasized by the backlight.

Side & Edge Lighting

↑ Leaning into the light
The distant setting sun serves as a strong edge light cast against the side of this boat, and molds around the contours of the sailor's taut muscles to communicate his physical exertion.

→ Side-lit Luxor
The monumental form of the columns and statues is best brought out by the strong side lighting of the rising sun. A careful exposure was required to keep detail in the shadows.

The long shadows typical of strong side lighting are evocative, dramatic, and highly effective at showing off fully rounded shapes. This lighting style is most apparent when the light source is shining at an exact right angle to the camera axis; but you can experiment with slight variations on that angle to see how the light interacts with your subject. It may be necessary at times to fill in strong shadows, which is often an easy task and requires only a reflector on the opposite side of the light.

As a point-source side light moves farther away from the subject, it gradually dims such that only the very edges are illuminated in a sort of outline. This is when side light becomes edge lighting, and is most effective with dark backgrounds that won't compete with the thin slivers of illumination. Likewise, it is best if the edge light doesn't have to compete with any other ambient light sources. Generally speaking, the simpler the shape and contour of the subject, the cleaner and clearer its outline will be when edge-lit. Too many different elements at varying distances to the camera will each pick up their own edge light and obscure a clear, underlying shape.

Texture

Being a two-dimensional representation, a photograph must use a number of tricks to communicate depth. Chiaroscuro lighting does this with very fine gradations of light to dark, which is excellent at communicating full shapes and figures; but textures are a much finer and smaller affair, and require strong side light at a very shallow angle to the subject's surface in order to cast a myriad of tiny shadows on a micro scale.

Toward that end, getting closer to the subject, either physically with a macro lens, or by zooming in with a long telephoto, makes it easier to discern the fine textural details brought out by a strong side light. Emphasizing texture also helps render a common subject in a more interesting way—what may look like just another concrete wall can, in the right light, reveal intricate patterns of crumbling masonry, chipped paint, weathered surfaces and so on.

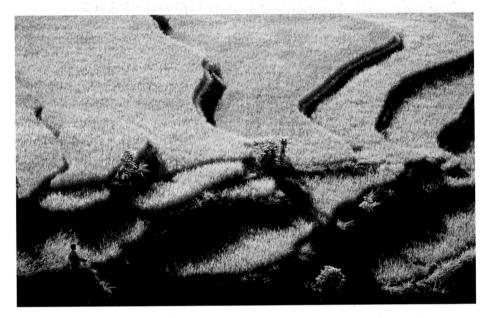

↑ Texture from afar
As distance between the subject and camera is increased, the intensity of the side light must also be increased if there is to be any discernible texture in the image. A diffuse light would have lost all the sharp detail in the blades of grass in these rice terraces.

→ Grandiose doorway
There are two types of shadows here: the larger, graphic one cast by the enormous doorway; and the infinite tiny shadows falling in all the indentations in the surface of the wall. A frontal light would be unable to illustrate those fine textural details, and the wall to the right would become an uninteresting component of the composition. As it is, however, you feel quite as if you could run your finger across the page and feel each groove and bump.

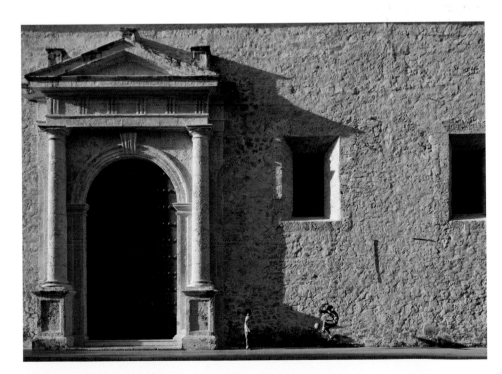

Edge & Backlighting

↓ Products on display
Display cases often use backlighting to show off various objects, and lend themselves well to a creative shot. Go explore some commercial spaces and don't be afraid to capitalize on the lighting designs that already exist.

You've already been challenged to shoot into the sun, which will normally impose a backlit scenario. Now you're challenged to capture a backlit shot using some other light source. You can set up this shot in your home studio if you like, and position your lights behind your subject. However, keep an eye out for backlit shots in the everyday as well; you'll be surprised how readily available they are. The substance of your subject will also come into play here—is it solid enough to completely block the source of the backlight? Or is it transparent/translucent, giving you an opportunity to look through the subject itself?

© Zoe - Fotolia

→ **Look up**

Sometimes all it takes to find a backlit shot is changing your angle in this case, looking straight up. Careful positioning and composition is key.

© Frank Gallaugher

Challenge Checklist

→ Spot metering is almost certainly the name of the game here, as the other metering modes are likely to get confused by the abundance of light in the frame and err on the side of overexposure.

→ Likewise, be ready to use some exposure compensation to make sure detail is captured in the important areas of the shot.

→ A lens hood is a good idea here—flare is easy enough to add in post-production, but quite painstaking to take out.

Review

© Kelly Jo Garner

Shonna Tucker of the Drive-by Truckers tends to hover in the background during live performances. I had to snake my way through the crowd at this show in Nashville, Tenn., and position her in front of a stage light in order to get any chance at focus. One of my favorite shots of her.
Kelly Jo Garner

The edge light is counterbalanced by enough frontal light that the subject isn't rendered in total silhouette. The resulting radiant outline does an excellent job of making the subject pop out of the frame.
Michael Freeman

Here the LED stage lights of M83
combined with fog machines made
the perfect backlighting for the
performers. The keyboard served as
a great way to block the direct light
source while still letting the rays pour
out around the silhouette.
Adam Graetz

Another concert shot, this one
is quite different in that it shows
how strong backlighting loses detail
and contrast. But the result is a nice
silhouette with great colors and
a hazy, atmospheric effect.
Michael Freeman

Bring Out the Texture

↓ Pastel close-up
Contrasting colors can impart a textural quality to a photograph all their own, and often the side lighting does not need to be terribly strong in order for them to take on an effective, three-dimensional appearance.

Most subjects can be said to have some degree of texture, but it's not always easy to capture it in every lighting condition. Strong side lighting will be the most apt lighting style for this challenge, which you can create in the studio, or find out in the field—either from artificial lamplight or from a low-angled sun early or late in the day. But unlike your challenge to capture golden light, the lighting itself is not the most important element of this challenge; rather, it's all about finding the right subject that will show off its three-dimensional qualities and come alive under the right conditions.

→ Love locks on a bridge

Bringing out the texture often means taking something that might otherwise be busy or overly complicated and making it the center of attention. This would have been a terrible portrait backdrop, for instance, but as a subject in itself, this wall of padlocks gives the eye a myriad of nooks and crannies to investigate.

Challenge Checklist

→ Macro and close-up shots lend themselves well to textural studies, and you can add a side light by either positioning a lamp in the right place, or by using an external flash unit attached by an accessory cord, which you can hold with one hand off to the side.

→ Longer, telephoto focal lengths are the natural inclination for textural shots, but keep in mind that most wide-angle lenses let you focus quite closely as well, and you may be able to get an interesting composition that pits large foreground elements against an expansive background.

Review

© Jennifer Laughlin

This photo was taken using a 55mm macro lens with an extension tube. Lit from the left of the subject with an external flash unit on an extension cord.
Jennifer Laughlin

You've got the off-camera flash in just the right position (left and above) to show the texture of the part in focus—not too hard and raking that the shadows are dense, but enough to reveal each strand of fiber.
Michael Freeman

© Adam Graetz

I do a lot of urban exploration, always with my camera in hand. This abandoned machinery, with its peeling paint and coat of rust was a great find—and the light coming from the side gave it just enough microcontrast to bring out the details.

Adam Graetz

Very attractive lighting! The slight pooling of light with shading on the lower right seems perfect for this machinery. Good location finding, as well.

Michael Freeman

Personal Lighting Styles

While a competent photographer is familiar with all the different lighting styles and equipment, they are unlikely to use all the skills and techniques discussed throughout this book in equal measure. It is only natural that, over time, they feel more and more comfortable working in a certain medium, and gradually that familiarity can blossom into their own unique lighting style. Sometimes it's called a "look," sometimes it's just a certain consistency across their portfolio (a quality much desired by many clients).

Some photographers call themselves "natural light photographers" and never touch a lamp or flash unit, seeking only to capture the undisturbed lighting conditions as they are found in the field. Others are dedicated strobists, always on a quest to bend and manipulate the light to their own end. Regardless of how it takes shape, a personal lighting style is the natural next step after learning all the concepts we've covered so far.

Developing a personal light style can seem intimidating to those newer to photography. The notion often encourages comparisons with photography masters who engage lighting in highly individualized and stylized methods. But a personal lighting style doesn't have to revolutionize the whole world of photography; in fact it rarely does. The key is simply to keep it personal, consistent, and loyal to your own vision—this is about what motivates you to take photographs.

The fact is that you already have a photographic style whether you are aware of it or not. Find it, embrace it, and explore it to its fullest potential.

← Shaker box
It's important to keep in mind the importance and relevance of color when thinking about your lighting style. Sometimes this means anticipating and visualizing what the results will be, particularly if you want to stray from a perfectly accurate representation of the scene.

Drawing Inspiration from Others

Other photographers can work to inspire your own style, although ultimately they should inform rather than dictate your approach. In particular, studying the work of others will help you understand the kind of style you are most drawn to, and this will help you settle on your own approach. It may be as basic as realizing which times of day give you the most appealing light, or as complex as delving deeper into how a photographer sets up their lighting rig. Browse through your photography books and magazines, and when a photo strikes you, take the time to study it. Where is the light coming from? Do you think they stumbled upon this shot, or did it require some particular piece of equipment? Probing beneath the surface of the image will spark your imagination and encourage you to experiment yourself.

↑ **Colors and shapes**
The studio is an excellent place to experiment with your lighting styles, as you can move at your own pace and have complete control over how the light affects the image.

Find Your Own Personal Lighting Style

↓ Low-contrast mist
A personal lighting style will be adaptable to each different subject that you encounter. For instance, this high-elevation shot was kept at very low contrast in order to preserve the dreamy and ethereal qualities that I found significant at the time.

This challenge, coming at the end of this book, is really just the beginning—the quest to discover your own unique lighting style will continue throughout your photographic career. Consider it a push out into the open. Take what you've learned and delve deeper. If you like arranging lighting rigs, try experimenting with building a grand setup and see what effects you can create. Maybe you want to explore different color casts for different subjects, and push the limits between representation and reality. You've learned a lot of rules in this book, and now that you understand their roles and why they exist, feel free to break them if that's what you need to do to achieve your vision.

→ Catching the light

In lively city environments, I often embrace a high-contrast lighting style, as it communicates the excitement and energy of the scene as I remember it.

Challenge Checklist

→ Feel free to break the rules, but do so with a purpose in mind.

→ Don't be afraid to fail; just be ready to try again.

→ Feel free to take inspiration from other photographs—but build on them or interpret them yourself.

© Jennifer Laughlin

This was my setup for my Biocommunications portrait project. The assignment was to have our subject pose in twelve different positions (six masculine & six feminine). This was taken with a Nikon D200 using hotlights.
Jennifer Laughlin

Everyone can appreciate a bit of meta-commentary on photographic lighting. This is a great spotlit silhouette, with interesting props and a main subject in a captivating pose.
Michael Freeman

© Adam Graetz

Here I wanted to experiment with different-colored LED lights, and tried to keep their painted shapes as defined as possible. It took several tries—fortunately, digital makes this kind of experimentation very easy (and quite enjoyable).
Adam Graetz

Light painting is a lot of fun, and with practice it gets easier to predict and control the results—definitely a worthwhile style to explore. I particularly like the compositional balance between the curved painting in the upper part of the frame and the spotlight in the foreground.
Michael Freeman

Glossary

aperture The opening in the camera lens through which light passes on its way to the image sensor (CCD/CMOS).

artifact A flaw in a digital image.

axis lighting Light aimed at the subject from close to the camera's lens.

backlighting The result of shooting with a light source, natural or artificial, behind the subject to create a silhouette or edge-lighting effect.

ballast The power pack unit for an HMI light which provides a high initial voltage.

barn doors The adjustable flaps on studio lighting equipment which can be used to control the beam emitted.

bit (binary digit) The smallest data unit of binary computing, being a single 1 or 0.

bit depth The number of bits of color data for each pixel in a digital image. A photographic-quality image needs eight bits for each of the red, green, and blue channels, making for a bit depth of 24.

boom A support arm for attaching and assembling studio lighting setups.

bracketing A method of ensuring a correctly exposed photograph by taking three shots; one with the supposed correct exposure, one underexposed, and one overexposed.

brightness The level of light intensity. One of the three dimensions of color in the HSB color system.
See also Hue *and* Saturation

byte Eight bits. The basic unit of desktop computing. 1,024 bytes equals one kilobyte (KB), 1,024 kilobytes equals one megabyte (MB), and 1,024 megabytes equals one gigabyte (GB).

calibration The process of adjusting a device, such as a monitor, so that it works consistently with others, such as scanners or printers.

candela Measure of the brightness of a light source itself.

CCD (Charge-Coupled Device) A tiny photocell used to convert light into an electronic signal. Used in densely packed arrays, CCDs are the recording medium in many digital cameras.

channel Part of an image as stored in the computer; similar to a layer. Commonly, a color image will have a channel allocated to each primary color (e.g. RGB) and sometimes one or more for a mask or other effects.

cloning In an image-editing program, the process of duplicating pixels from one part of an image to another.

CMOS (Complementary Metal-Oxide Semiconductor) An alternative sensor technology to the CCD, CMOS chips offer certain benefits for larger sensor sizes and high-ISO shooting.

CMYK (Cyan, Magenta, Yellow, Key) The four process colors used for printing, including black (key).

color gamut The range of color that can be produced by an output device, such as a printer, a monitor, or a film recorder.

color temperature A way of describing the color differences in light, measured in Kelvins and using a scale that ranges from dull red (1900 K), through orange, to yellow, white, and blue (10,000 K).

compression Technique for reducing the amount of space that a file occupies, by removing redundant data. There are two kinds of compression: standard and lossy. While the first simply uses different, more processor-intensive routines to store data than the standard file formats (see LZW), the latter actually discards some data from the image. The best known lossy compression system is JPEG, which allows the user to choose how much data is lost as the file is saved.

contrast The range of tones across an image, from bright highlights to dark shadows.

cropping The process of removing unwanted areas of an image, leaving behind the most significant elements.

depth of field The distance in front of and behind the point of focus in a photograph, in which the scene remains in acceptably sharp focus.

dialog box An on-screen window, part of a program, for entering settings to complete a procedure.

diffusion The scattering of light by a material, resulting in a softening of the light and of any shadows cast. Diffusion occurs in nature through mist and cloud cover, and can also be simulated using diffusion sheets and soft-boxes.

digital zoom Many cheaper cameras offer a digital zoom function. This simply crops from the centre of the image and scales the image up using image processing algorithms (indeed the same effect can be achieved in an image editor later). Unlike a zoom lens, or optical zoom, the effective resolution is reduced as the zoom level increases; 2× digital zoom uses ¼ of the image sensor area, 3× uses ⅑, and so on.

dye sublimation printer A color printer that works by transferring dye images to a substrate (paper, card, etc.) by heat, to give near photographic-quality prints.

edge lighting Light that hits the subject from behind and slightly to one side, creating flare or a bright 'rim lighting' effect around the edges of the subject.

feathering In image-editing, the fading of the edge of an image or selection.

file format The method of writing and storing information (such as an image) in digital form. Formats commonly used for photographs include TIFF, BMP, and JPEG.

fill flash A technique that uses the on-camera flash or an external flash in combination with natural or ambient light to reveal detail in shadows.

fill light An additional light used to supplement the main light source. Fill can be provided by a separate unit or a reflector.

filter (1) A thin sheet of transparent material placed over a camera lens or light source to modify the quality or color of the light passing through. (2) A feature in an image-editing application that alters or transforms selected pixels for some kind of visual effect.

flag Something used to partially block a light source to control the amount of light that falls on the subject.

flash meter A light meter especially designed to verify exposure in flash photography. It does this by recording values from the moment of a test flash, rather than simply measuring the live light level.

focal length The distance between the optical center of a lens and its point of focus when the lens is focused on infinity.

focal range The range over which a camera or lens is able to focus on a subject (for example, 0.5m to infinity).

focus The optical state where the light rays converge on the film or imaging sensor to produce the sharpest possible image.

fringe In image-editing, an unwanted border effect to a selection, where the pixels combine some of the colors inside the selection and some from the background.

frontal light Light that hits the subject from behind the camera, creating bright, high-contrast images, but with flat shadows and less relief.

f-stop The calibration of the aperture size of a photographic lens, used to determine precisely how much light is allowed through the lens and onto the sensor. Also used in the determination of depth of field.

gamma A measure of the contrast of an image, expressed as the steepness of the characteristic curve of an image.

gobo Anything used to block or partially block light, particularly when it contributes a shape or texture to the light as it falls on the scene—much like a stencil.

gradation The smooth blending of one tone or color into another, or from transparent to colored in a tint. A graduated lens filter, for instance, might be dark on one side, fading to clear on the other.

grayscale An image made up of a sequential series of 256 grey tones, covering the entire gamut between black and white.

halogen bulb Common in modern spotlighting, halogen lights use a tungsten filament surrounded by halogen gas, allowing it to burn hotter, longer and brighter.

haze The scattering of light by particles in the atmosphere, usually caused by fine dust, high humidity, or pollution. Haze makes a scene paler with distance, and softens the hard edges of sunlight.

HDRI (High Dynamic Range Imaging) A method of combining digital images taken at different exposures to draw detail from areas which would traditionally have been over or under exposed. This effect is typically achieved using a Photoshop plugin, and HDRI images can contain significantly more information than can be rendered on screen or even perceived by the human eye.

histogram A map of the distribution of tones in an image, arranged as a graph. The horizontal axis goes from the darkest tones to the lightest, while the vertical axis shows the number of pixels in that range.

HMI (Hydrargyrum Medium-arc Iodide) A lighting technology known as "daylight" since it provides light with a color temperature of around 5600 K.

honeycomb grid In lighting, a grid can be placed over a light to prevent light straying. The light can either travel through the grid in the correct direction, or will be absorbed by the walls of each cell in the honeycomb.

hot-shoe An accessory fitting found on most digital and film SLR cameras and some high-end compact models, normally used to control an external flash unit. Depending on the model of camera, information to lighting attachments might be passed via the metal contacts of the shoe.

HSB (Hue, Saturation, Brightness) The three dimensions of color, and the standard color model used to adjust color in many image-editing applications.

hue The pure color defined by position on the color spectrum; what is generally meant by "color" in lay terms.

incandescent lighting This strictly means light created by burning, referring to traditional filament bulbs. They are also know as hotlights, since they remain on and become very hot.

incident meter A standalone light-measuring instrument, distinct from the metering systems built into many cameras. These are used by hand to measure the light falling at a particular place, rather than (as the camera does) the light reflected off of a particular subject.

ISO An international standard rating for film speed and imaging sensor sensitivity, with the sensitivity increasing as the rating increases. ISO 400 is twice as sensitive as ISO 200, and will produce a correct exposure with less light and/or a shorter exposure. However, higher ISOs tend to produce more grain and noise in the exposure, too.

Joule Measure of power, *see* watt-seconds.

JPEG (Joint Photographic Experts Group) Pronounced "jay-peg," a system for compressing images, developed as an industry standard by the International Standards Organization. Compression ratios are typically between 10:1 and 20:1, although lossy (but not necessarily noticeable to the eye).

kelvin Scientific measure of temperature based on absolute zero (simply take 273.15 from any temperature in Celsius to convert to kelvin). In photography, measurements in kelvin refer to color temperature. Unlike other measures of temperature, the degrees symbol is not used.

LCD (Liquid Crystal Display) Flat screen display used in digital cameras and some monitors. A liquid-crystal solution held between two clear polarizing sheets is subject to an electrical current, which alters the alignment of the crystals so that they either pass or block the light.

light pipe A clear plastic material that transmits light, like a prism or optical fiber.

light tent A tent-like structure, varying in size and material, used to diffuse light over a wider area for close-up shots.

lumens A measure of the light emitted by a lightsource, derived from candela.

luminaires A complete light unit, comprising an internal focusing mechanism and a fresnel lens. An example would be a focusing spot light. The name luminaires derives from the French, but is used by professional photographers across the world.

luminosity The brightness of a color, independent of the hue or saturation.

lux A scale for measuring illumination, derived from lumens. It is defined as one lumen per square meter, or the amount of light falling from a light source of one candela one metre from the subject.

macro A mode offered by some lenses and cameras that enables the lens or camera to focus in extreme close-up.

megapixel A rating of resolution for a digital camera, directly related to the number of pixels forming or output by the CMOS or CCD sensor. The higher the megapixel rating, the higher the resolution of images created by the camera.

midtone The parts of an image that are approximately average in tone, falling midway between the brightest highlights and the darkest shadows.

modeling light A small light built into studio flash units which remains on continuously. It can be used to position the flash, approximating the light that will be cast by the flash.

monobloc An all-in-one flash unit with the controls and power supply built-in. Monoblocs can be synchronized together to create more elaborate lighting setups.

noise Random pattern of small spots on a digital image that are generally unwanted, caused by electrical signals that do not form an image themselves.

open flash The technique of leaving the shutter open and triggering the flash one or more times, perhaps from different positions in the scene.

peripheral An additional hardware device connected to and operated by the computer, such as a drive or printer.

pixel (PICture ELement) The smallest units of a digital image, pixels are the square screen dots that make up a bitmapped picture. Each pixel carries a specific tone and color.

photoflood bulb A special tungsten light, usually in a reflective dish, which produces an especially bright (and if suitably coated white) light. The bulbs have a limited lifetime.

plug-in In image-editing, software produced by a third party and intended to supplement another program's features or performance.

power pack The separate unit in flash lighting systems (other than monoblocks) which provides power to the lights.

ppi (pixels-per-inch) A measure of resolution for a bit-mapped image.

processor A silicon chip containing millions of micro-switches, designed for performing specific functions in a computer or digital camera (in which it converts the information captured by the sensor into an editable, viewable image file).

RAID (Redundant Array of Independent Disks) A stack of hard disks that function as one, but with greater capacity.

RAM (Random Access Memory) The working memory of a computer, to which the central processing unit (cpu) has direct, immediate access.

Raw files A digital image format, known sometimes as the "digital negative," which preserves higher levels of color depth than traditional 8 bits per channel images. The image can then be adjusted in software—potentially by three f-stops—without loss of quality. The file also stores camera data including meter readings, aperture settings and more. In fact, most camera models create their own kind of proprietary Raw file format, though leading models are supported by software like Adobe Photoshop.

reflector An object or material used to bounce available light or studio lighting onto the subject, often softening and dispersing the light for a more attractive end result.

resampling Changing the resolution of an image either by removing pixels (lowering resolution) or adding them by interpolation (increasing resolution).

resolution The level of detail in a digital image, measured in pixels (e.g. 1,024 by 768 pixels), or dots-per-inch (in a half-tone image, e.g. 1200 dpi).

RFS (Radio Frequency System) A technology used to control lights where control signals are passed by radio rather than cable. It has the advantage of not requiring line-of-sight between the transceiver and device.

RGB (Red, Green, Blue) The primary colors of the additive model, used in monitors and image-editing programs.

ring-flash A lighting device with a hole in the centre so that the lens can be placed through it, resulting in shadow-free images.

satellite In lighting, this is a parabolic dish designed to reflect and diffuse light.

saturation The purity of a color, going from the lightest tint to the deepest, most saturated tone.

scrim A light, open-weave fabric, used to cover softboxes.

selection In image-editing, a part of an on-screen image that is chosen and defined by a border in preparation for manipulation or movement.

shutter The device inside a conventional camera that controls the length of time during which the recording medium (sensor) is exposed to light. Many digital cameras don't have a shutter, but the term is still used as shorthand to describe the electronic mechanism that controls the length of exposure for the imaging sensor.

shutter speed The time the shutter (or electronic switch) leaves the sensor open to light during an exposure.

SLR (Single Lens Reflex) A camera that transmits the same image via a mirror to the film and viewfinder, ensuring that you get exactly what you see in terms of focus and composition.

slow sync The technique of firing the flash in conjunction with a slow shutter speed (as in rear-curtain sync).

snoot A tapered barrel attached to a lamp in order to concentrate the light emitted into a spotlight.

soft-box A studio lighting accessory consisting of a flexible box that attaches to a light source at one end and has an adjustable diffusion screen at the other, softening the light and any shadows cast by the subject.

spot meter A specialized light meter, or function of the camera's light meter, that takes an exposure reading for a precise area of a scene.

sync cord The electronic cable used to connect camera and flash.

telephoto A photographic lens with a long focal length that enables distant objects to be enlarged.

TIFF (Tagged Image File Format) A file format for bitmapped images. It supports CMYK, RGB, greyscale files with alpha channels, lab, indexed-color, and LZW lossless compression. It is now the most widely used standard for high-resolution digital images.

top lighting Lighting from above, useful in product photography as it removes reflections.

TTL (Through The Lens) Describes metering systems that use the light passing through the lens to evaluate exposure details.

tungsten A metallic element, used as the filament for lightbulbs, hence tungsten lighting.

umbrella In photographic lighting umbrellas with reflective surfaces are used in conjunction with a light to diffuse the beam.

vapour discharge lamp A lighting technology common in stores and street lighting. It tends to produce color casts.

white balance A digital camera control used to balance exposure and color settings for artificial lighting types.

window light A softbox, typically rectangular (in the shape of a window) and suitably diffused.

zoom A camera lens with an adjustable focal length, giving, in effect, a range of lenses in one. Drawbacks include a smaller maximum aperture and increased distortion over a prime lens (one with a fixed focal length).

Index

Bibliography and Useful Addresses

Books

The Complete Guide to Light and Lighting in Digital Photography
Michael Freeman

The Photoshop Pro Photography Handbook
Chris Weston

Perfect Exposure
Michael Freeman

Mastering High Dynamic Range Photography
Michael Freeman

Pro Photographer's D-SLR Handbook
Michael Freeman

The Complete Guide to Black & White Digital Photography
Michael Freeman

The Complete Guide to Night & Lowlight Photography
Michael Freeman

The Art of Printing Photos on Your Epson Printer
Michael Freeman & John Beardsworth

Digital Photographer's Guide to Adobe Photoshop Lightroom
John Beardsworth

The Photographer's Eye
Michael Freeman

The Photographer's Mind
Michael Freeman

Websites

Note that website addresses may often change, and sites appear and disappear with alarming regularity. Use a search engine to help find new arrivals.

Photoshop sites
Absolute Cross Tutorials
www.absolutecross.com

Laurie McCanna's Photoshop Tips
www.mccannas.com
Planet Photoshop
www.planetphotoshop.com
Photoshop Today
www.designertoday.com
ePHOTOzine
www.ephotozine.com

Digital imaging and photography sites
Creativepro
www.creativepro.com
Digital Photography
www.digital-photography.org
Digital Photography Review
www.dpreview.com
Short Courses
www.shortcourses.com

Software
Alien Skin
www.alienskin.com

ddisoftware
www.ddisoftware.com

DxO
www.dxo.com

FDRTools
www.fdrtools.com

Photoshop, Photoshop Elements
www.adobe.com

PaintShop Photo Pro
www.corel.com

Photomatix Pro
www.hdrsoft.com

Toast Titanium
www.roxio.com

Useful Addresses

Adobe www.adobe.com

Apple Computer www.apple.com

BumbleJax www.bumblejax.com

Canon www.canon.com

Capture One Pro
www.phaseone.com/en/Software/
Capture-One-Pro-6 Corel
www.corel.com

Epson www.epson.com

Expression Media
www.phaseone.com/expressionmedia2

Extensis www.extensis.com

Fujifilm www.fujifilm.com

Hasselblad www.hasselblad.se

Hewlett-Packard www.hp.com

Iomega www.iomega.com

Kodak www.kodak.com

LaCie www.lacie.com

Lightroom www.adobe.com

Microsoft www.microsoft.com

Nikon www.nikon.com

Olympus www.olympusamerica.com

Pantone www.pantone.com

Philips www.philips.com

Photo Mechanic www.camerabits.com

PhotoZoom www.benvista.com

Polaroid www.polaroid.com

Ricoh www.ricoh-europe.com

Samsung www.samsung.com

Sanyo www.sanyo.co.jp

Sony www.sony.com

Symantec www.symantec.com

Wacom www.wacom.com